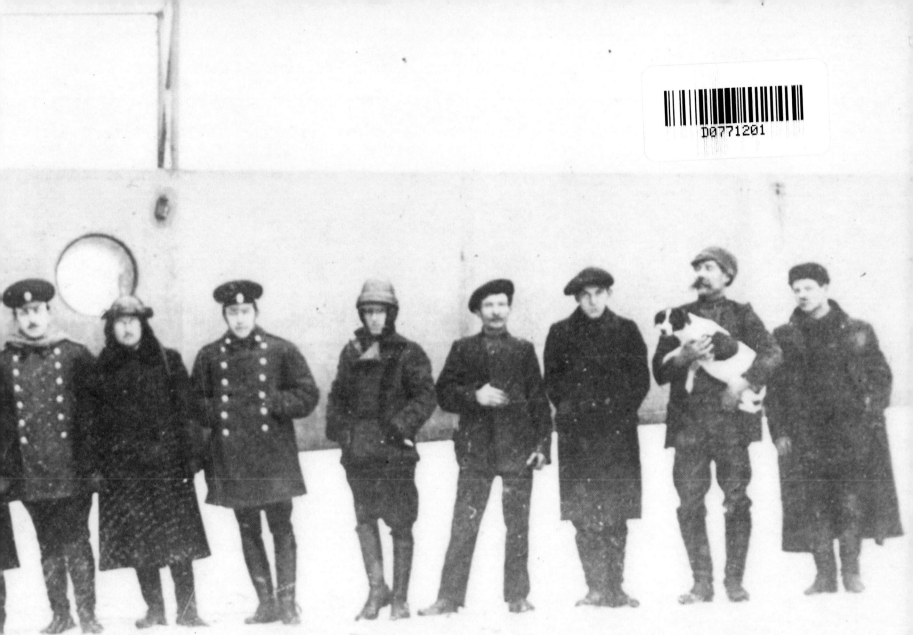

Animals Aloft

Photographs from the Smithsonian National Air and Space Museum

www.bunkerhillpublishing.com

First published in 2005 by Bunker Hill Publishing Inc.
285 River Road, Piermont, NH 03779 USA

10 9 8 7 6 5 4 3 2 1

ISBN 1 59373 048 9

Designed by Louise Millar

Printed in China

Endpapers: Following a two-hour sightseeing flight over St. Petersburg, Igor Sikorsky (fourth from the left) poses with his passengers - fifteen friends and a dog named Shkalika – beside Sikorsky's prototype *Il'ya Muromets* aircraft. February 1914.

Half title Page: Louis Blériot in flight in his Blériot VIII*ter*, October 31, 1908.

Title Page: A mountain goat gazes admiringly at a Hanriot H 46 in a cover illustration by Benjamin Rabier for an *Avions Hanriot* brochure.

Animals Aloft

Photographs from the Smithsonian National Air and Space Museum

ALLAN JANUS

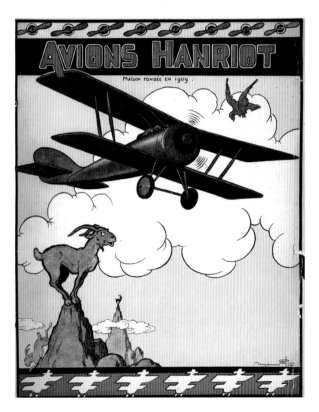

BUNKER HILL PUBLISHING

Picture Credits

Sources: NASM – Smithsonian National Air and Space Museum, SI – Smithsonian Institution, SIL – Smithsonian Institution Libraries, IMP – Imperial War Museum, NASA – National Aeronautics and Space Administration, RAFM – Royal Air Force Museum, Hendon, USAF – U.S. Air Force.

NASM Archives Division Collections: George Allison Photograph Collection, Rudy Arnold Photo Collection, Beech Aircraft Corporation Collection, Bowman Family Papers, Herbert Stephen Desind Collection, Nathaniel L. Dewell Collection, Sherman Fairchild Collection, John Guy Gilpatric Collection, Hans Groenhoff Photographic Collection, William Rigby Jacobs Collection, Ruth Law Collection, Joseph Pace Collection, Roland Rohlfs Collection, Robert Soubiran Collection, Paul R. Stockton Scrapbook Collection

Endpapers: SI 82-1997; **Half-title page:** SI 2003-11324, **Title page:** NASM 7A26564; **Page 7:** SI 89-15688; **8:** SI A-39094-F – SIL; **9:** SI A-19864-C – SIL; **10:** SI 72-5745 (top), NASM 2A02871 (bottom); **11:** SI 90-6528; **12:** NASM 9A02173; **13:** NASM 7B01370; **14:** SI 88-8142; **15:** SI 91-15199 (left), SI 2003-29081 (right) via Library of Congress; **16:** SI 2001-11720 via Library of Congress, L'Aérophile Coll.; **17:** AC71-3A (left), AC71-3B (right) – RAFM; **18:** SI 87-9050; **19:** SI 2001-11615 via Library of Congress, L'Aérophile Coll.; **20:** SI 80-15370; **21:** NASM 9A00699; **22:** SI 85-18299 (left), SI 94-4476 (right); **23:** NASM 2B08938 (top), NASM 1A00134 (bottom); **24:** SI A-31247-G; **25:** SI-93-14656; **26:** NASM-1A43992; **27:** SI-2002-997 (left), SI-2002-995 (right); **28:** SI-96-15130; **29:** NASM-2A07018 (left), NASM 2A06987 (right); **30:** NASM-2B33622; **31:** NASM-2A04728 (left), SI 98-15258 (right); **32:** SI 96-16334; **33:** NASM-2B23118, Rohlfs; **34:** SI 2001-2676; **35:** SI 78-7888, Soubiran ; **36:** SI A-48748-T, Soubiran; **37:** SI 2002-21019 (left), NASM 2B11409, Gilpatric (right); **38:** SI 76-13305 (left), SI 76-13975 (right); **39:** SI-78-14098 (left), NASM 2B22446 (right); **40:** SI 2002-1267; **41:** SI 74-10080 (left), SI A-25367-A (right); **42:** NASM 9A02248, Stockton (left), SI 9A01525, Law (right); **43:** NASM 1A44295; **44:** SI A-42064-C; **45:** USAF 118023AC; **46:** SI-96-15134; **47:** NASM 2B05433 (left), NASM 7B01437 (right); **48:** NASM 9A 01994 (left), NASM 2B29018 (right); **49:** XRA-8302, Arnold; **50:** XRA-8122, Arnold (left), XRA-8080, Arnold (right); **51:** HGD-122-03, Groenhoff; **52:** SI 85-10828 (top), NASM 7A30213 (bottom); **53:** NASM-2A 40888; **54:** SI 91-7029, Dewell (left), NASM 1A49553 (right); **55:** SI 75-15168 (left), SI 97-16604 (right); **56:** NASM 9A01213 (left), SI 90-6603 (right, top), NASM 2B18163, Fairchild (bottom); **57:** NASM 9A02335; **58:** NASM 2A04835; **59:** SI 81-16768 (left), NASM 9A03062 (right); **60:** HGC-838-B, Arnold (left), SI 77-4172, Beech (right); **61:** NASM 7B47481 (left), SI 92-8955 (right, top), SI 92-8952 (right, bottom) – Bowman; **62:** SI 99-40528; **63:** SI 87-16237 (left), NASM 7B06596 (right); **64:** SI 78-13936 (left), SI 89-8855 (right); **65:** NASM 9A01655; **66:** HGC-1124, Groenhoff; **67:** NASM 9A02205, Groenhoff (left), XRA-1801, Arnold (right); **68:** XRA-2093, Arnold; **69:** XRA-1551, Arnold; **70:** SI 97-17023, USAF; **71:** SI 97-17024, USAF; **72:** NASM 9A03056 (top, left), USAF 59279AC (top, right), SI 97-17022 (left, bottom) – USAF; **73:** USAF-K1661A; **74:** 9A02336, IMP (left), SI 74-2939 (right); **75:** SI 92-13863 (left), 2A45552 (right, top), SI 74-3126 (right, bottom); **76:** NASM 9A03055 (left), NASM 9A03050 (right); **77:** NASM 9A02203 (left), NASM 9A02201 (right) – Jacobs; **78:** SI A-4571 (top, left), XRA-6283, Arnold (left, bottom), XRA-6284, Arnold (right); **79:** HGD-087-11 (left), HGD-087-07 (right, top), HGD-087-22 (right, bottom) – Groenhoff; **80:** SI 89-15509 (top), SI 89-15517 – Pace; **81:** SI 89-15528, Pace; **82:** HGC-90, Groenhoff; **83:** HGC-143, Groenhoff (left), XRA-1185, Arnold (right); **84:** XRA-0856 (left), XRA-5745 (top, right), XRA-0452 (bottom, right) – Arnold; **85:** SI 91-13262 (top), NASM 7A24801 (bottom, left), NASM 7A24687 (bottom, center), NASM 7A24834 (bottom, right); **86:** NASM 7B47641, Bowman (top, left), HGC-1228, Groenhoff (bottom, left), SI 95-8323 (right); **87:** HGC-1117, Groenhoff; **88:** NASM 7B21889, NASA; **89:** NASM 2A44384 (top, left), SI 75-10226 (bottom, left), NASM 9A02067, Desind (right); **90:** SI 2003-4850 (top), NASM 7B21527 (bottom) – NASA; **91:** NASM 9A02974; **92:** NASM 9A02334, Desind (left), SI 83-5366, Allison (right); **93:** NASM 7B27673 (left), NASM 7B27681 (right) – NASA; **94:** SI 2000-3882; **95:** NASM 9A02162, NASM 9A02163

Introduction

The National Air and Space Museum's Archives Division has, among its collections, over one and a half million photographs of aviators and aircraft, spacecraft, and a variety of aeronautical related subjects. As one might expect, there are photographs of airships, engines, and air races. Curiously, however, there are many images of animals in the museum's files. In fact, it's a much larger photographic menagerie than one would ever expect to find in an aerospace museum. Apart from dogs and cats, there are horses and cows, as well as monkeys, pigeons, lions, goats, and chickens. There are even photos of a flying pig, a transatlantic woodchuck, and a couple of Earth-orbiting spiders. Many of the animals were mascots – pets that accompanied the troops during the World Wars as morale boosters for the war effort. Other critters, such as the dog and cat Tray and Tabitha, served as test subjects that made the first American parachute jumps in 1837 while their master John Wise wisely remained in his balloon. Others did their work in the air, like the messenger pigeons of the World Wars and the Air Force's para-rescue dogs. Some were on board as passengers – or cargo, depending on one's point of view. And some of them just happened to be hanging around when the cameras were snapping. In a way, these pictures present another side of the history of aeronautics – one that was not only a record of human endeavors in flight, but also the contribution of the animal kingdom. Although men and women may have always dreamed of taking to the sky, the photographic evidence suggests that we've also liked having our favorite companions and helpers nearby.

Not all of the images here show an obvious aviation connection – the Museum's photographs have come to us from many sources over the years, and some collections of mainly aeronautical photographs also included a few non-aero snaps. If these pictures happened to feature something in the animal line, the temptation to include them sometimes just couldn't be resisted.

The names of the photographers are noted when they are known.

Acknowledgments

Many colleagues at the National Air and Space Museum were very generous with their advice, assistance, and knowledge. Patricia Graboske, the Museum's publications officer, first suggested that there might be a book somewhere in my bulky folders of animal images. In the Archives Division, Dr. Thomas Soapes, the supervisory archivist, allowed me to devote time to this project, and he patiently listened to my explanations when the time that I required mysteriously expanded. His successor, Marilyn Graskowiak, was similarly patient. Other colleagues recommended particular images, suggested collections to explore, identified aircraft, corrected my rare historical errors and misspellings, and helped tremendously in the daunting logistics of putting a book together. Among them I would particularly like to thank Dana Bell, Dan Hagedorn, Kate Igoe, Kristine Kaske, Brian Nicklas, Paul Silbermann, Barbara Weitbrecht, and Larry Wilson. Photo archivist Melissa Keiser was especially generous with her time, assistance, and splendid advice. In the Museum's Aeronautics Division, Dorothy Cochrane, Tom Crouch, Peter Jakab, and Bob van der Linden were very helpful, as was Valerie Neal in the Space History Division, Hanna Szczepanowska of the Conservation Unit, Phil Edwards of the Smithsonian Institution Library branch at the Museum, and Eric Long, Smithsonian Photographic Services. A special note of gratitude goes to Andrew Renwick, curator of photographs at the Royal Air Force Museum, Hendon, for locating a copy of the rare photograph of the first pig to fly. And for patience and forbearance on the home front, my thanks go to Rebecca and to the two decidedly earthbound cats, Max and Maxine.

Of course, it was the animals who were the first to take to the skies. Meanwhile, we watched from the ground and dreamed and imagined what flight would be like, creating myths about man's ability to fly. And when Étienne and Joseph Montgolfier launched the original passenger-carrying balloon on September 19, 1783, the first intrepid aeronauts were a sheep, a duck, and a rooster. In his report of the ascent to his wife, Étienne spoke for the flyers:

> "We feel fine. We've landed safely despite the wind. It's given us an appetite." That is all we could gather from the talk of the three travelers, seeing that they don't know how to write and that we neglected to teach them French. The first could only say "Quack, quack"; the second, "Cock-a-doodle-doo"; and the third, no doubt a member of the Lamb family, replied only "Baa" to all our questions.

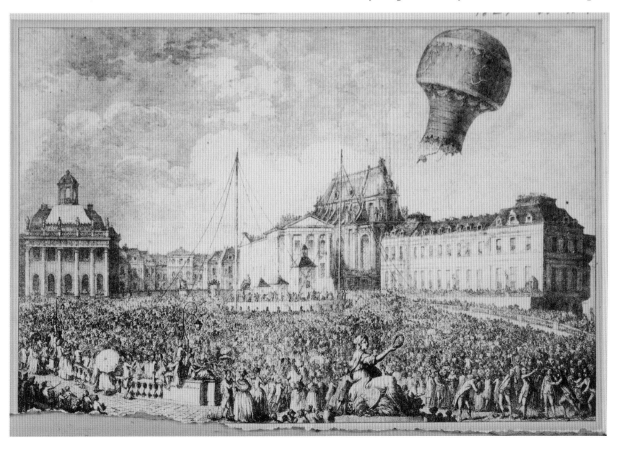

Ascent of the Montgolfier "Animal Flight," Versailles, September 19, 1783.

A satire of the
Montgolfier
"Animal Flight."
*Engraving by
John Norman.*

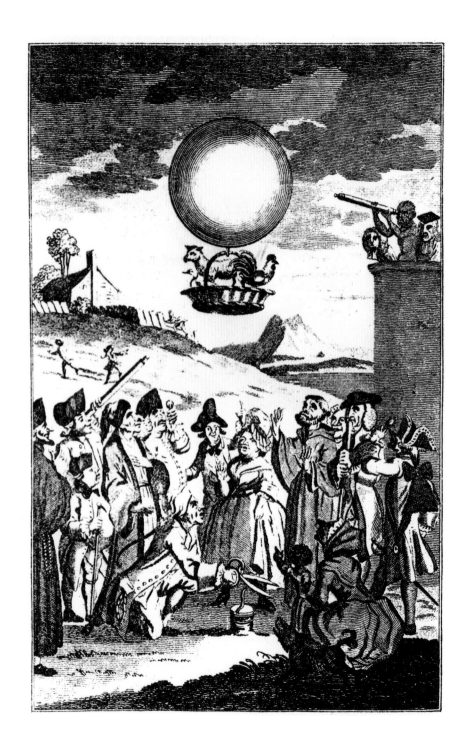

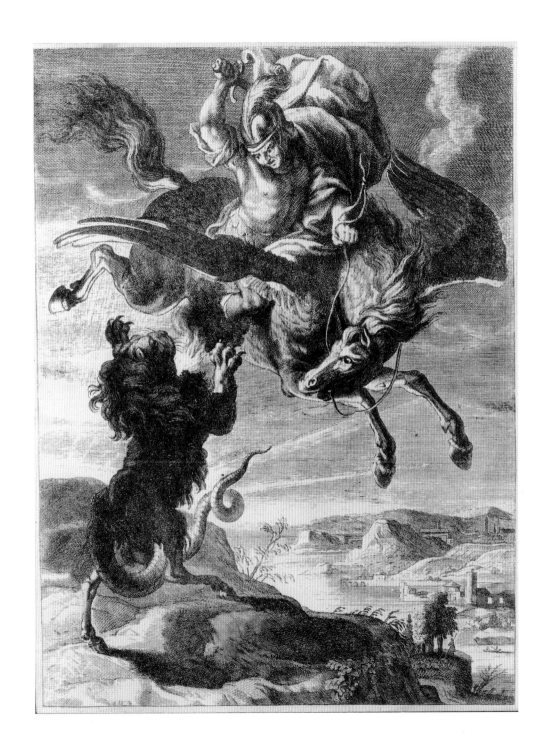

Bellerophon, mounted on the winged horse Pegasus, fights the Chimaera.

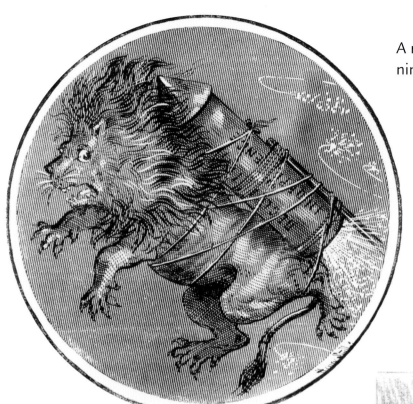

A rocket-powered lion, from a nineteenth-century magazine.

Pierre Testu-Brissy made the first balloon ascension on horseback on October 16, 1798. All went fairly well, except for the horse's nosebleed.

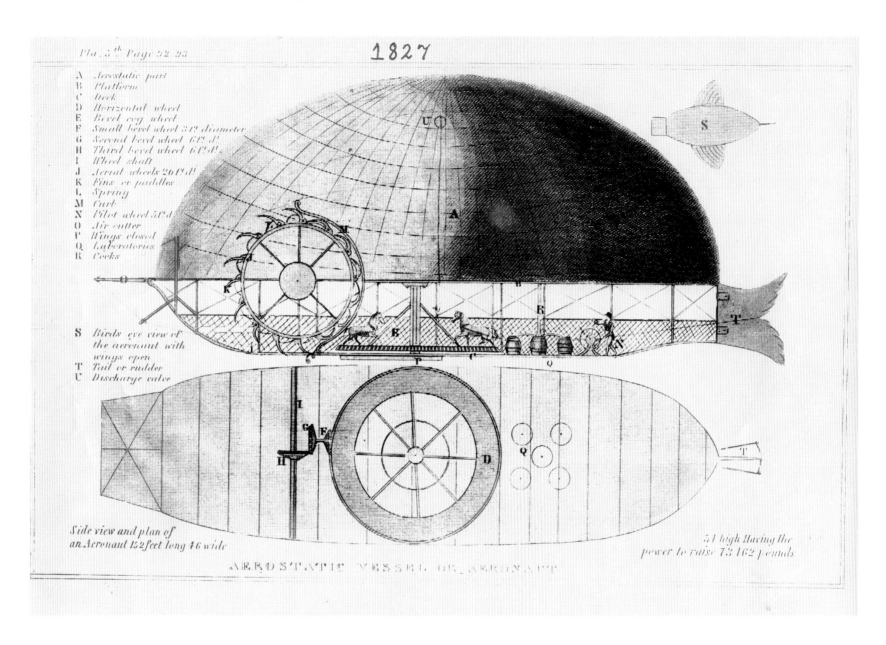

In 1825, Edmond Charles Genêt proposed a two-horse-powered airship named the *Aeronaut* or *Aerostatic Vessel;* the horses were to propel a horizontal treadmill and twin side-wheels. Though Genêt actually received a patent for the design, it never got past the planning stage, much less off the ground.

11

When men and women began to take to the skies in gliders, dirigibles, and airplanes, it didn't take long for them to be joined by dogs, cats, and even a pig. Dogs, especially, seemed to enjoy the excitement and activity of the early airfields; horses in nearby fields were probably a bit more reserved.

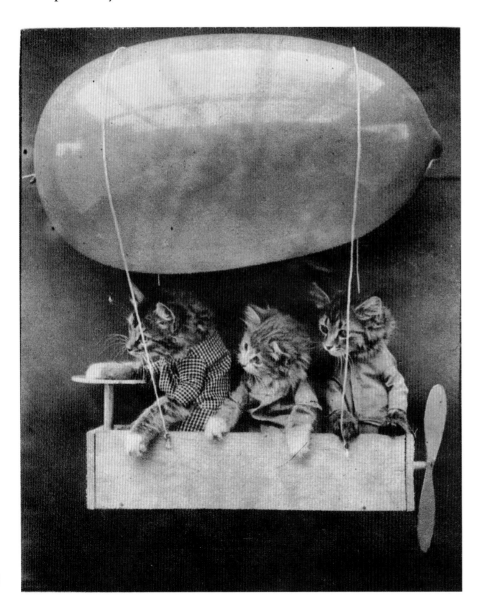

The photographer Harry Whittier Frees made a specialty of dressing up small animals and documenting their jolly adventures. The original caption reads:

All Aboard for Cloudland —
Left — Susie and her little sister were a little nervous when they began their first ride on the transcontinental blimp express. Only the pilot appeared confident.

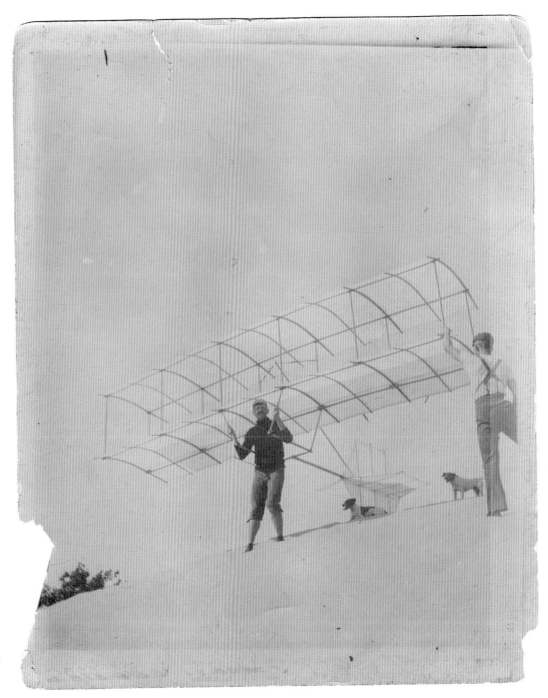

Augustus Moore Herring prepares to launch himself in his biplane glider from the Indiana Dunes, 1897, closely observed by Octave Chanute's dogs, Rags and Tatters. *Photograph by Octave Chanute.*

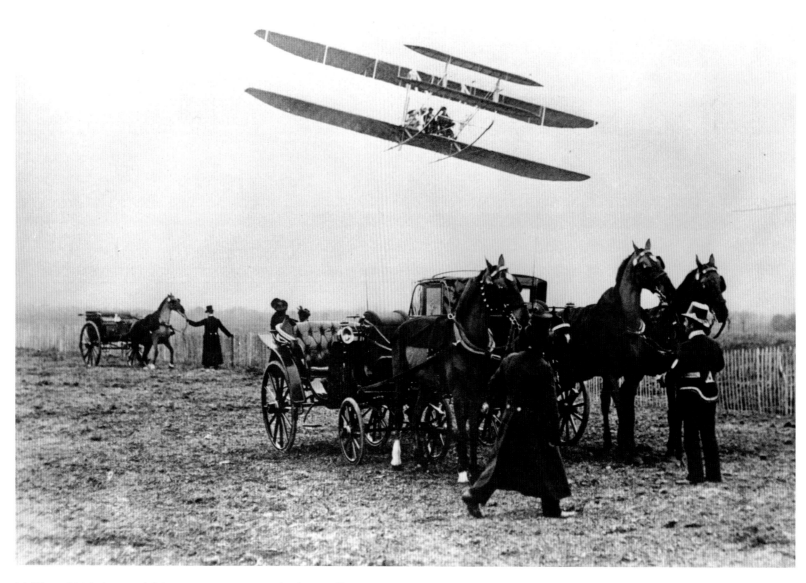

Wilbur Wright and his passenger, Paul Tissandier, soar over carriage horses at Pau, France, in 1909.

On December 14, 1903, Wilbur and Orville Wright attempted their first powered flight on Kill Devil Hill, North Carolina. Assisting were crewmen from the local lifesaving station, two boys, and a dog. That flight attempt was unsuccessful, but the brothers succeeded brilliantly on December 17, making four flights – although without a dog being present.
Photograph by Orville or Wilbur Wright.

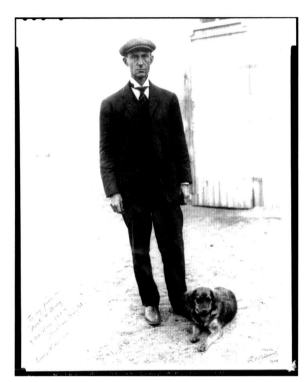

Wilbur Wright with an unidentified friend, Camp d'Auvours, France, 1908. The Wright family had a St. Bernard named Scipio, and Orville carried his photograph in his wallet for decades after the dog's death.
Photograph by L. Bouveret.

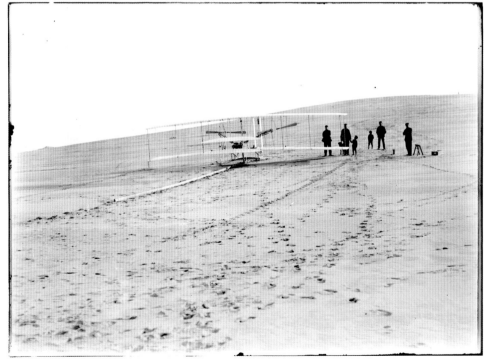

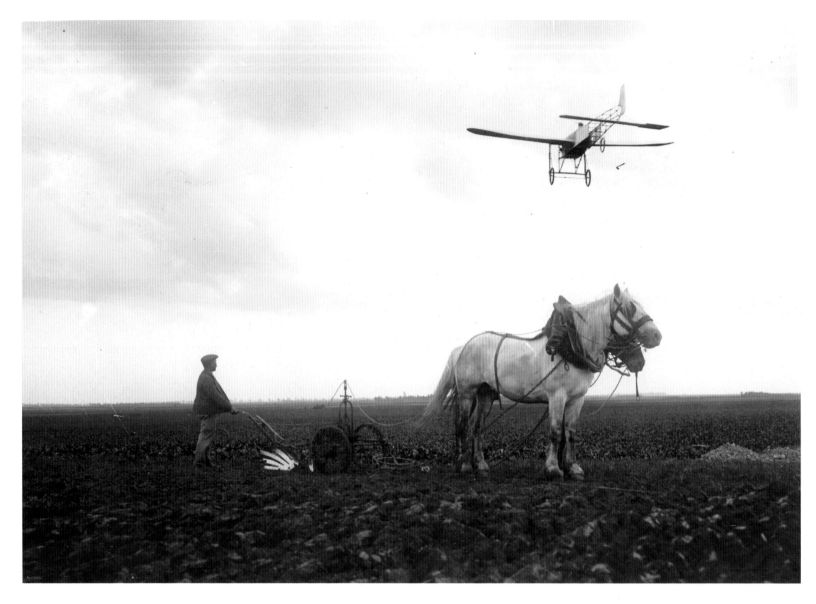

A French farmer watches Louis Blériot soar overhead in his Blériot XI while the team takes a breather, c. 1909. *Photograph by Rol & Cie.*

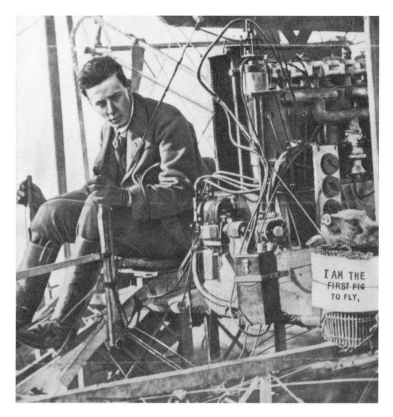

John Theodore Cuthbert Moore-Brabazon (later Lord Brabazon of Tara) made the first officially recognized flight by a British pilot in Great Britain, on April 30, 1909. Not long after, he proved to the world that pigs really are capable of flight. The French journal *La Revue de l'Aviation* reported on the historic flight:

> The English aviator Moore Brabazon (sic) ... had the rather extravagant idea to fly with a little pig which was perched in a wicker basket with this inscription ... : "I am the first pig to fly."
> The little pig did not fly for very long, but during the voyage it emitted, it is said, some grunts of satisfaction ... or fear

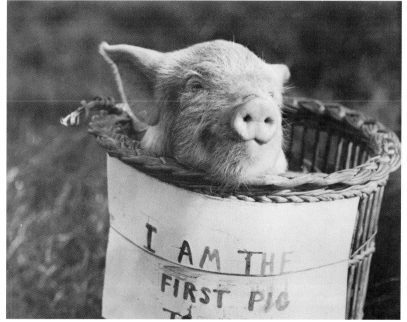

This does not look like a frightened piglet – rather the opposite, in fact. Could the French correspondent have been unaware of the proverbial phrase "when pigs fly ... ?"

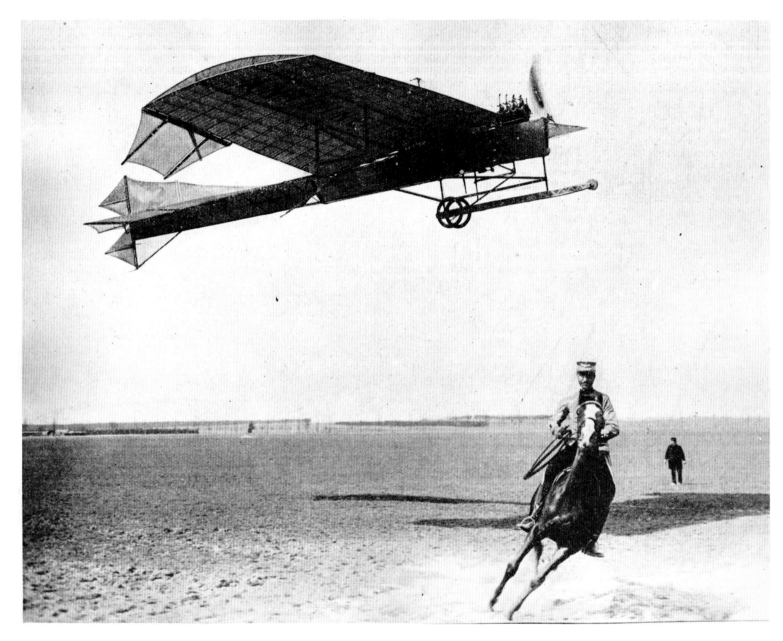

In the war that was soon to come, cavalry would give way to reconnaissance from the air. The Antoinette IV takes off over a trooper and his mount, probably at Camp de Châlons, France, c.1908-09.

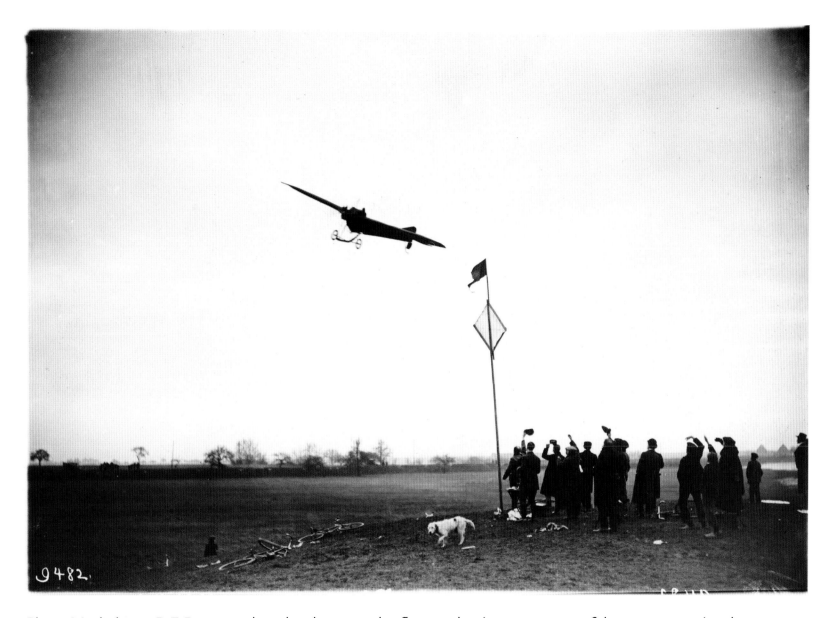

Pierre Marie in an R.E.P. monoplane banks around a flag marker in an unsuccessful attempt to win t he
Coupe Michelin, Buc, France, c.1911.
Photograph by Meurisse.

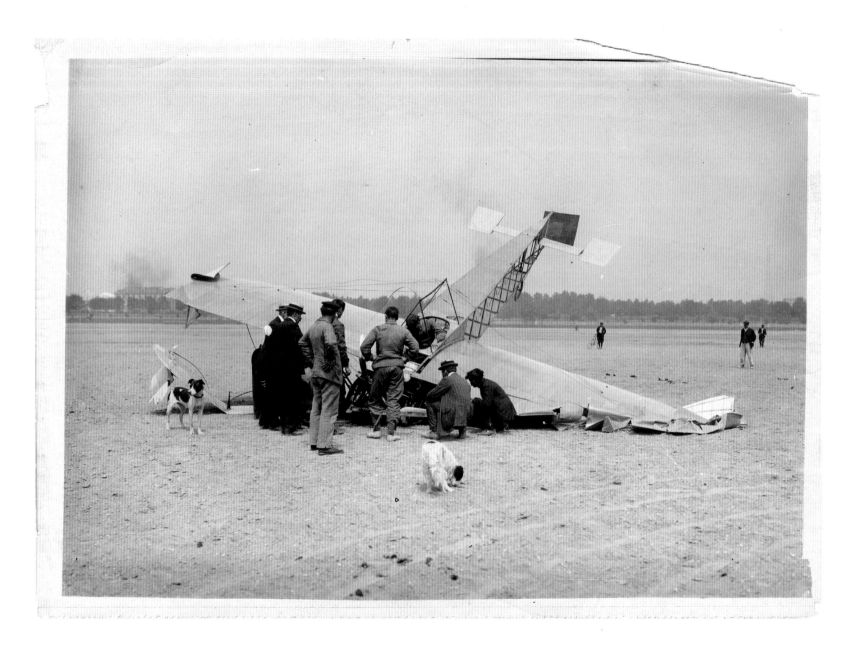

Dogs and onlookers gather after Louis Blériot makes a difficult landing in the Blériot VIII*bis*, Issy-les-Moulineaux, Paris, 1908.

Photograph by Rol & Cie.

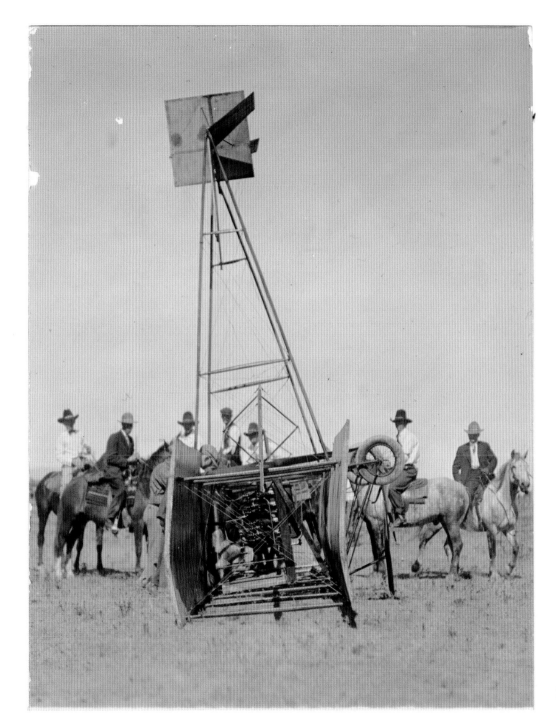

Cowboys and their mounts gather for the last round-up of an unidentified Curtiss-type biplane at a Glendive, Montana rodeo and air show, 1916.

In the first decade of flight, a unique breed of dog appeared: the Spotted Cockpit Terrier. Conveniently small for those cramped early aircraft cockpits, they gave off a surprising amount of heat – very comforting in those drafty open crates.

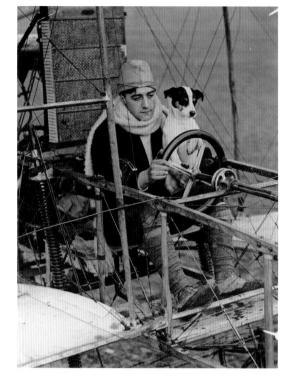

Edmond Poillot and his *chien d'avion* in a Voisin biplane at the Farman Aviation School, Mourmelon, France, c.1913.

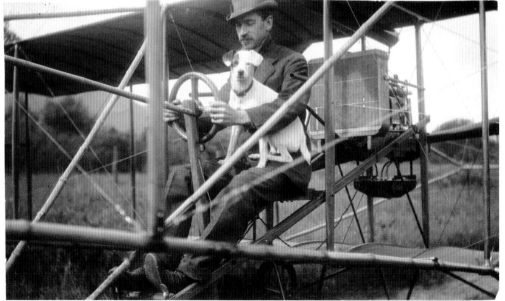

Dog is his copilot – Glenn Curtiss and friend going through their preflight checklist in one of Curtiss' pushers, c.1912.

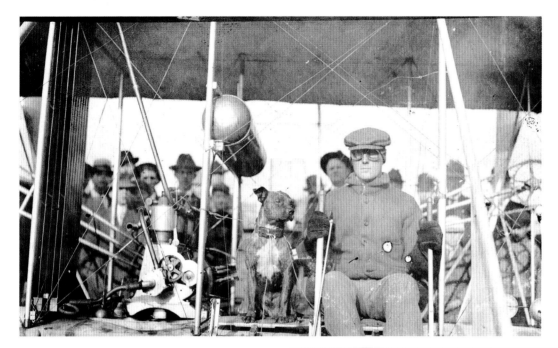

Robert G. Fowler's passenger is securely restrained prior to a flight in Fowler's Wright Model B. In 1911, Fowler attempted the first U.S. transcontinental flight by air, but was beaten by Cal Rogers in his Wright EX Vin Fiz. On April 27, 1913, Fowler made an ocean-to-ocean flight across the Isthmus of Panama (accompanied by a cameraman, but no dog) in his Gage Tractor Biplane, which he donated to the National Air and Space Museum in 1950.

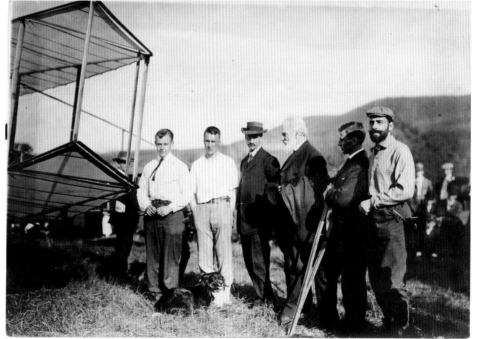

Members of the Aerial Experiment Association and Jack the dog with one of the AEA's designs, the Aerodrome No. 2 *White Wing*, Hammondsport, New York, 1908. Glenn Curtiss is third from the left; next to him on the right is Alexander Graham Bell.

A year after Louis Blériot's 1909 aerial crossing of the English Channel, John Moisant attempted the first Paris-to-London flight. Landing near Upchurch in Kent, he was handed a kitten, which he named Paree-Londres. The kitten, traveling in a paper bag, accompanied Moisant and his mechanic Albert Fileux on several stages of the journey, which took three weeks. After one particularly hair-raising landing, Moisant remarked to reporters:

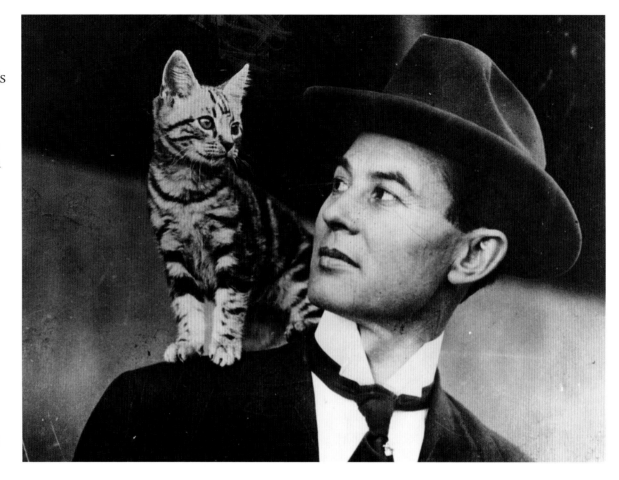

"You ought to have seen this kitten. He enjoyed himself immensely and wasn't a bit afraid. He was still curled up in the bag, his bright eyes peeping up at me when the crash came, and even the noise of breaking wood did not disturb him."

On later, closer examination, Paree-Londres turned out to be a she, rather than a he; she was also known as Miss Paris. When she disappeared from Moisant's hotel suite, the worried aviator enlisted the hotel staff to search for her. Paree-Londres was eventually found in the hotel's laundry room (putting an end to rumors that she had been catnapped by a rival flyer) and returned to Moisant, who, "... faint with relief, embraced his beloved pet and handed the laundry girl $25.00."

24

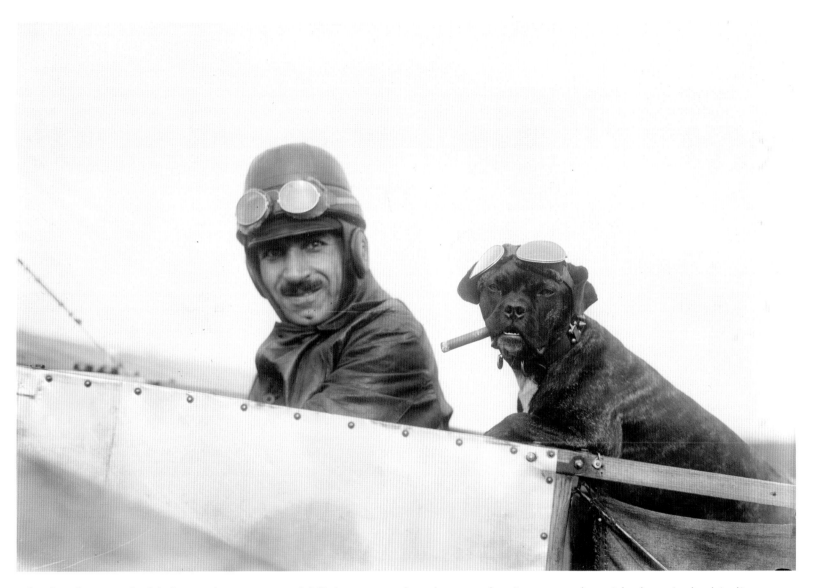

Ah, for the good old days when you could light up on the plane and enjoy a smoke with the wind whistling through your fur … . Shakir S. "Dude" Jerwan, chief pilot of the Moisant Aviation School, Mineola, Long Island, does the work while his dog Monoplane puffs contentedly, July 1912. The Moisant school was founded by John Moisant's brother Alfred.

Photograph by Joseph Burt.

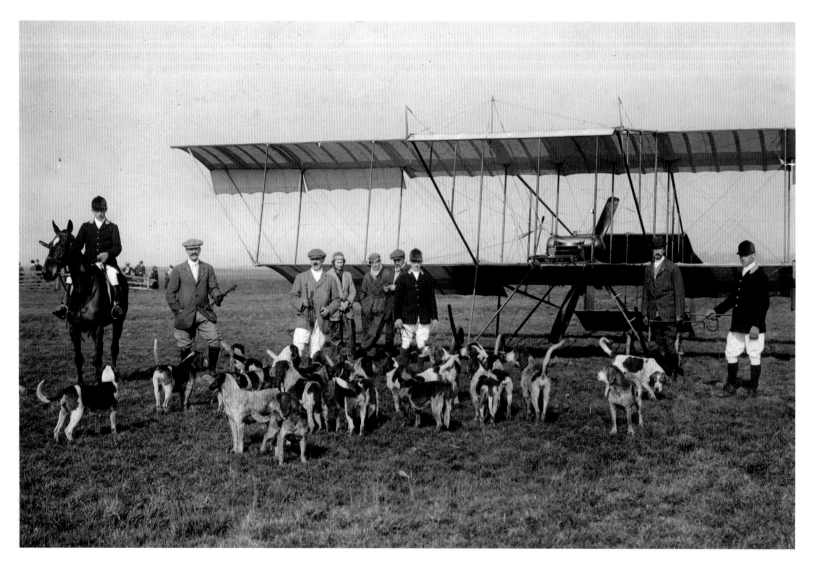

Fox hunting is sometimes called "riding to hounds" – the aerial version, "flying to hounds," doesn't seem to have gotten off the ground, so to speak. For one thing, one would hate to have one's clothes, the expensive hunting pinks, stained by motor oil. And dropping a salvo of bombs on poor old Renard the fox was so terribly unsporting … . But F. B. Fowler, "The Eastbourne Aviator," did try aerial hare-hunting at least once. Here he prepares to coordinate close-air support with the Hailsham Harriers in a Henry Farman H.F. III biplane, c.1909.

There are photographs in the Museum's collections that, at first glance, seem to have little to do with aviation. These images from a family album document the early years of James H. "Jimmy" Doolittle, who would grow up to become one of the outstanding flyers of the twentieth century – air racer, pioneer of instrument flight, leader of the Tokyo Raiders, and later of the Eighth Air Force during World War II. But growing up in Nome, Alaska, there was plenty of time to sit around with the Doolittle dogs and to pose with his mother Rosa and the Doolittle family cat. The amazing feats, the achievements, and the heroism would come later.

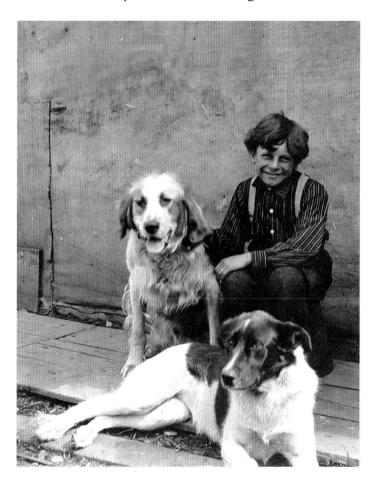 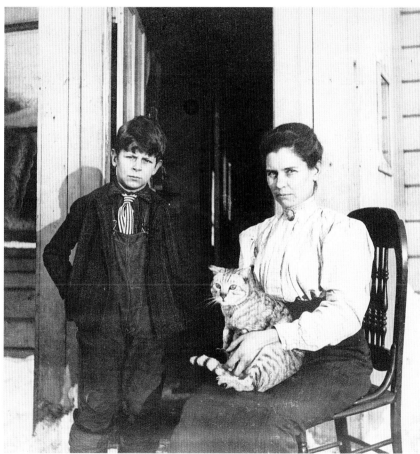

The distinction of being the first cat to attempt to cross the Atlantic by airship belongs to Kiddo, a gray tabby. The pet of a member of the crew of Walter Wellman's *America*, Kiddo was reported to have stowed away in the airship's lifeboat before the takeoff from Atlantic City, New Jersey on October 15, 1910. Initially, he didn't enjoy the experience, howling piteously and upsetting the airship's chief engineer, Melvin Vaniman. The *America* was the first aircraft to carry radio equipment, and Vaniman ordered a wireless message sent to Wellman's secretary back on shore – so the historic first radio communication from an aircraft in flight reads:

"Roy, come and get this goddamn cat."

The crew stuffed Kiddo into a canvas bag and attempted to lower him into a following motorboat. But the sea was too rough for the transfer to take place, and Kiddo remained on board the *America*. He quickly recovered his spirits, and the airship's navigator, Murray Simon, suggested to prospective adventurers that "You must never cross the Atlantic in an airship without a cat. We have found our cat more useful to us than any barometer. He is sitting on the sail of the lifeboat now as I write, washing his face in the sun, a pleasant picture of feline content. This cat has always indicated trouble well ahead. Two or three times when we thought we were 'in' he gave most decided indications that he knew we would shortly be getting it in the neck."

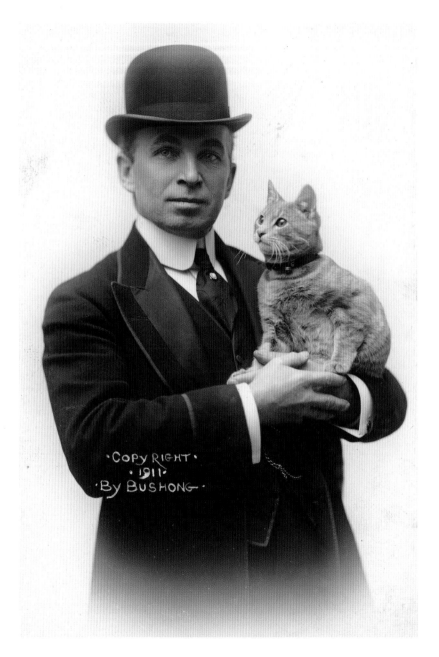

Kiddo with Melvin Vaniman, chief engineer of the airship America. *Photograph by Bushong.*

America flew for 71¹/₂ hours, breaking all records for sustained flight up to that time. But it finally came down in the sea 475 miles east of the Maryland coast.

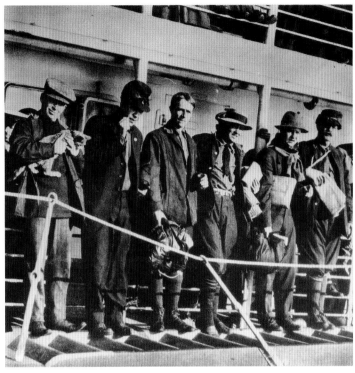

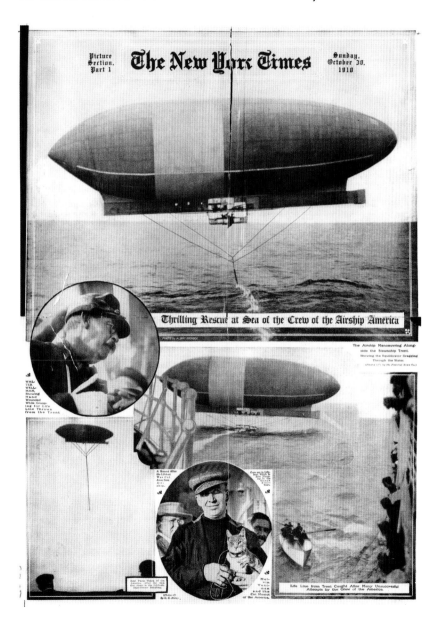

The exhausted crew and cat were rescued by the steamer *Trent*. "Told you it was a good idea to have a cat along – cats have nine lives!" navigator Simon reminded the crew. They returned to New York City for a hero's welcome – Kiddo was even displayed in splendor at Gimbel's department store on plush cushions in a gilded cage. In 1912, Melvin Vaniman made another transatlantic attempt in the airship *Akron*. Tragically, the airship exploded on July 2, 1912, and all aboard were killed. But Kiddo had already retired from aviation and lived on in the home of Walter Wellman's daughter.

The quantity of photographs from World War I of dashing young pilots with their mascots strongly suggests that the war in the air depended on the morale-raising effect of the dogs, goats, and lions that supported the squadrons. And pigeons bravely flew through shot and shell, delivering vital messages.

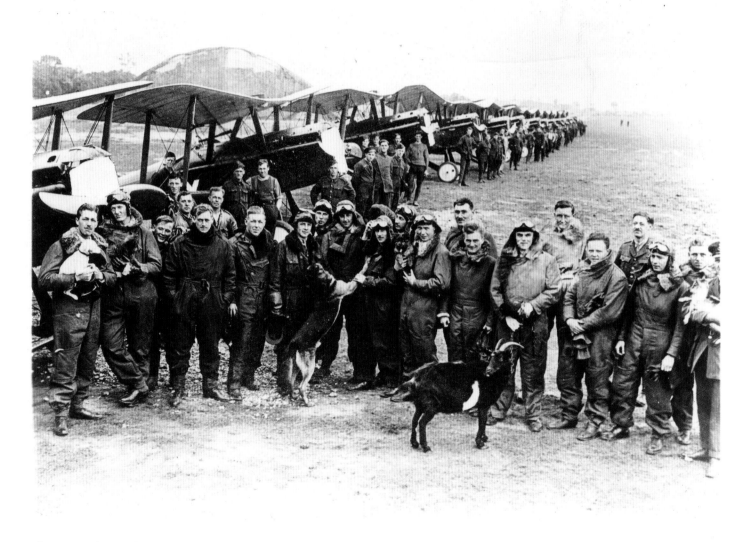

The squadron dogs and goat pose with pilots of the Royal Flying Corps in front of their S.E.5 scout planes, somewhere in France.

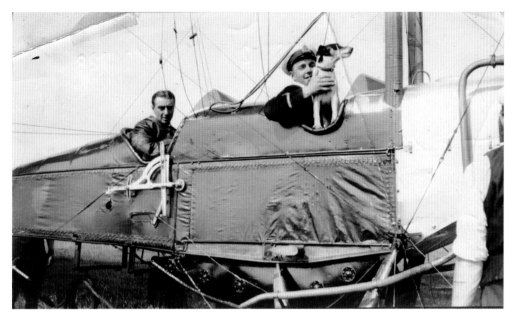

A terrier shows his heroic profile from the cockpit – a converted aircraft fuselage – of a British Royal Naval Air Service SS (Sea Scout) airship, c.1915.

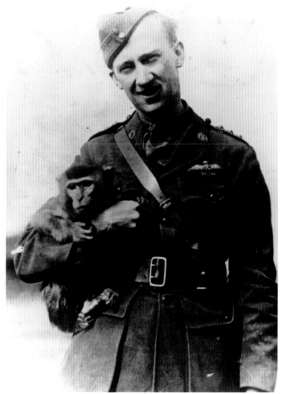

Before the war, the ballroom dancers Vernon and Irene Castle were the toast of Broadway, originating such dances as the Castle Walk, the Turkey Trot, and the unforgettable Grizzly Bear. Castle, a British subject, returned to England in 1916 to join the Royal Flying Corps. At the front, he was known for his coolness and good humor. Between missions, Castle gave dancing lessons to his fellow pilots – as he explained, "When you know that every one of them ... faces death nearly every day, it doesn't seem at all out of place that they should dance" Transferred to Canada and later to Texas to serve as a flight instructor, Captain Vernon Castle was killed in a flying accident in February 1918 at Benbrook Field, near Fort Worth. Here he is with his monkey Jeffry. He also served with a champion German shepherd, Tell von Flugelrad.

31

This may get a bit confusing – we have a picture of an American pilot in the cockpit of a British fighter with a dog named for the famous Dutch designer of German aircraft. Fokker the bull terrier and Lt. Field E. Kindley, 148th Aero Squadron, U.S. Air Service, in the cockpit of Kindley's Sopwith Camel, September 1918.

U.S. Army Signal Corps photograph.

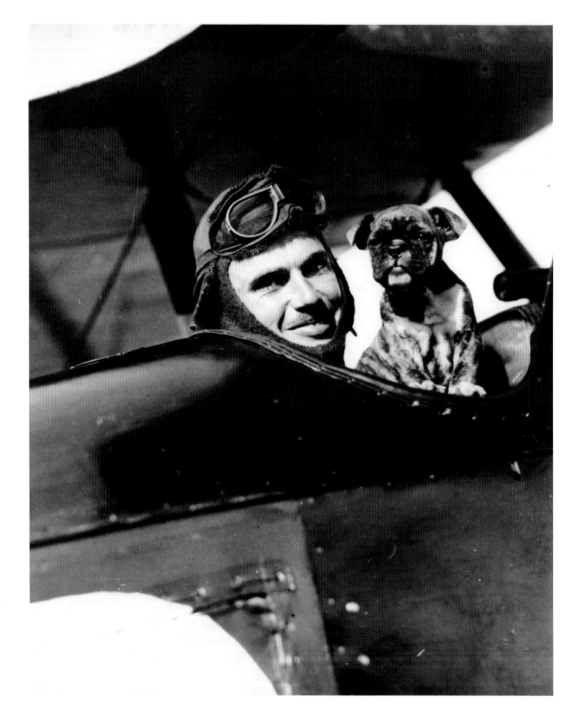

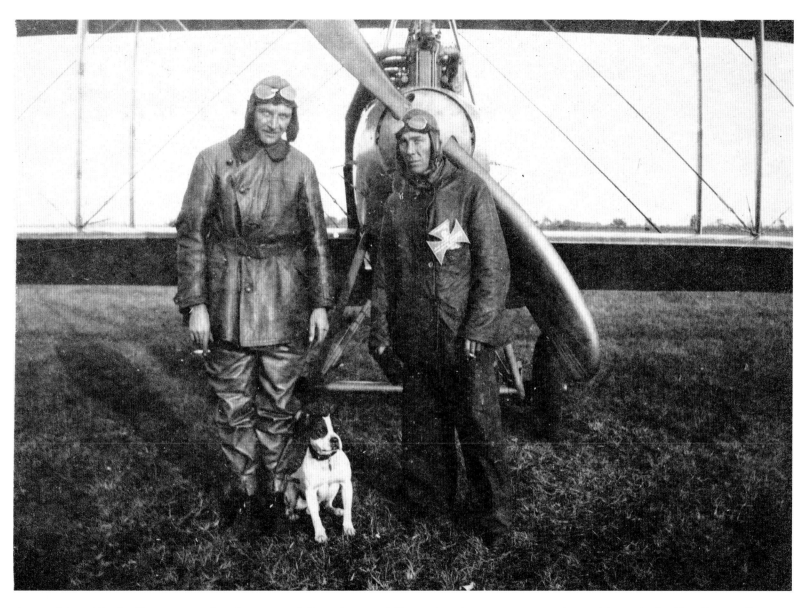

An unidentified pilot, a mechanic named Brooks, and Don the dog prepare to buzz New York City for a Liberty Bond rally in a Lowe, Willard & Fowler V-2 biplane, c.1918. The pilot, in a hard-to-decipher note on the back of the photograph, claimed that Don was the first dog to fly over New York. He could be right; to turn a phrase, every Don has his day.

The American volunteers to the French Air Service served in several squadrons known collectively as the Lafayette Flying Corps. The best known of the squadrons was Escadrille N-124, also known as the Escadrille Américaine and later as the Lafayette Escadrille. This collection of fearless aviators, hard-living and deep-drinking, soon collected an equally colorful collection of mascots: dogs and cats, mostly, but also some fairly exotic specimens. One pilot bought a fox that bit him repeatedly and proved generally unsympathetic, and after a disagreement with Fram, the Escadrille's commander's dog, the fox ended up as a fur neckpiece for the pilot's *chérie*. Esther the civet cat, an animal closely related to the skunk, turned out to be rather too close a relative for the olfactory comfort of squadron personnel. But they were all fondly remembered – one of the Escadrille's pilots, Edwin Parsons, later wrote a heart-felt tribute to all those mascots who served:

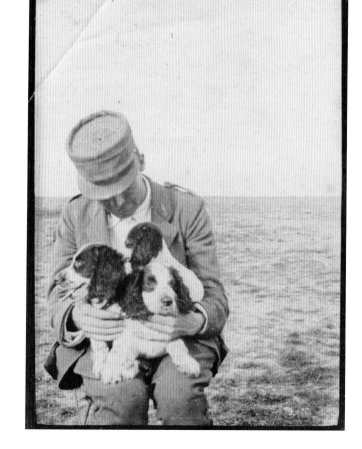

> "To all those dumb friends of ours, I, for one, am deeply grateful. They deserved a citation every bit as much as we humans, for they were our constant companions and comforts in all the black hours and endured every hardship with us cheerfully and uncomplainingly. Knowing that we loved and appreciated them, may their souls rest peacefully in the animal heaven."

Didier Masson of the Lafayette Escadrille with a lap full of spaniels. One of them was named "Carranza the Comedian," recalling Masson's earlier career as chief (and sole pilot) of the Mexican air service.

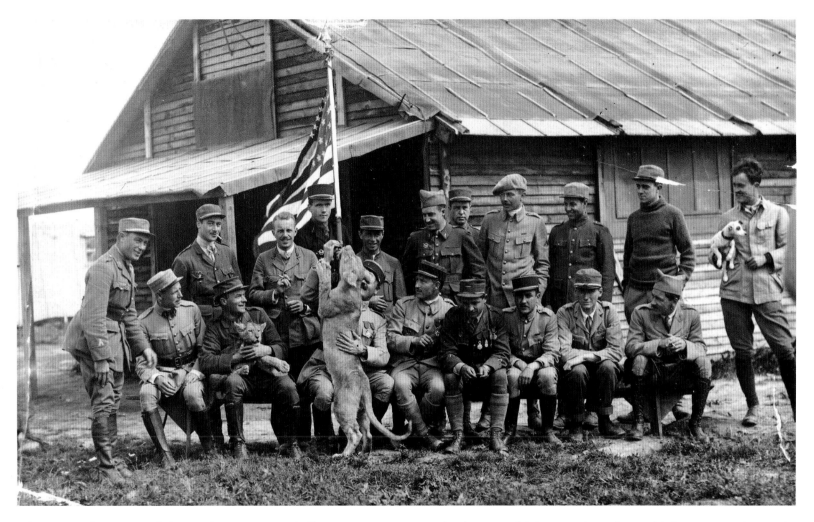

The most famous of the Lafayette Escadrille's mascots were the lions Whiskey and Soda. Whiskey was adopted as a cub: "... a cute, bright-eyed baby who tried to roar in a most ferocious manner, but who was blissfully content the moment one gave him a finger to suck." Whiskey was friendly; he enjoyed pouncing from ambush on unsuspecting soldiers and chewing on articles of uniform. Soda was more stand-offish. She adored Whiskey, but didn't enjoy being petted and played with as Whiskey did. Sadly, the brass of the U.S. Air Service didn't take to the lions, and when the Lafayette Escadrille was transferred to the Air Service in February 1918, Whiskey and Soda were exiled to the Paris Zoo. But they're commemorated on the Lafayette Escadrille Memorial at Villeneuve l'Etang near Paris with life-size sculptures. *Robert Soubiran Collection.*

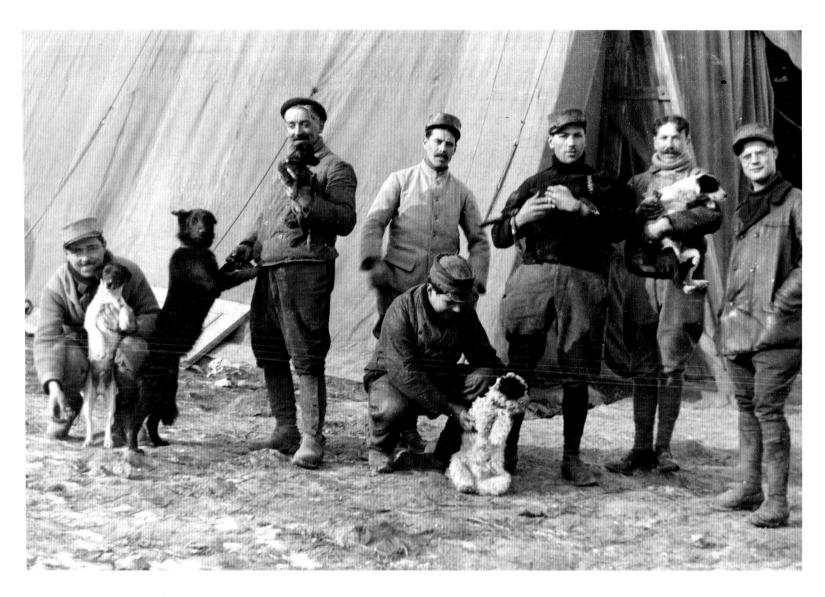

Even the Lafayette Escadrille's ground crew was generously supplied with mascots.
Robert Soubiran Collection.

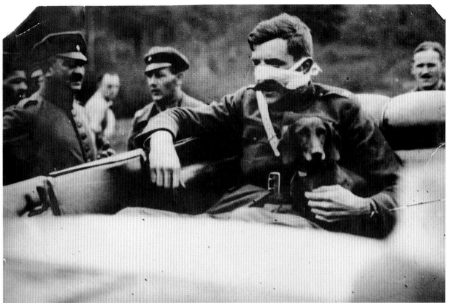

James Norman Hall, later co-author of the Bounty trilogy, was also a pilot of the Lafayette Escadrille. He was shot down and taken prisoner by the Germans in May 1918. Hall later wrote "I had a homesick moment while sitting [in the car], thinking of the uncertain future ... helpless and sick at heart." The German pilots were hospitable, though, and gave him lunch in their mess. And the squadron's dachshund was available for aid and comfort. *John Guy Gilpatric Collection.*

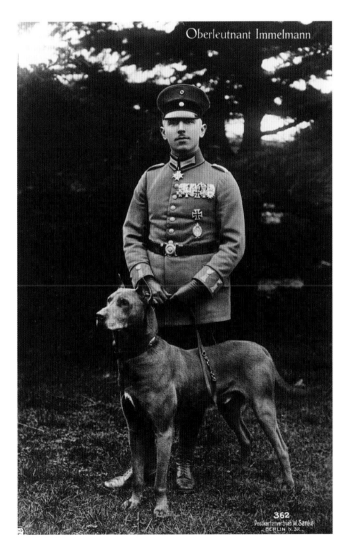

Oberleutnant Immelmann

And on the other side of the trenches, German pilots had their mascots, too.

Max Immelmann, one of the first of the great German aces, known as "the Eagle of Lille," with Tyras the Doberman pinscher. 37

Some pilots liked their mascots small and fluffy.

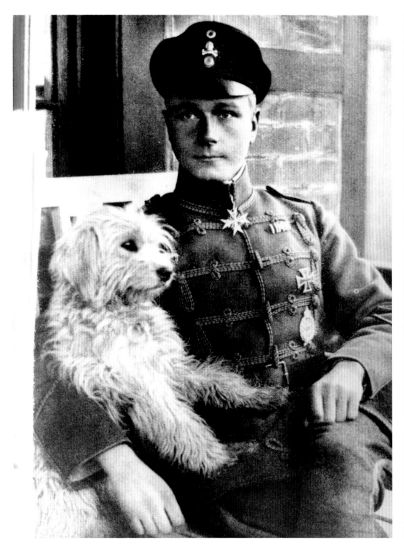

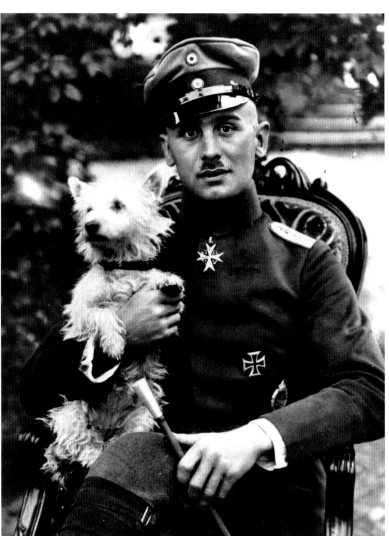

Walter von Bülow-Bothkamp, 28 aerial victories.

Rudolf Berthold, 44 aerial victories.

... And some, like the Red Baron, Manfred von Richthofen, liked their mascots a bit bigger.

Rittmeister Manfred Freiherr von Richthofen (center) with Moritz and pilots of his famous "Flying Circus."

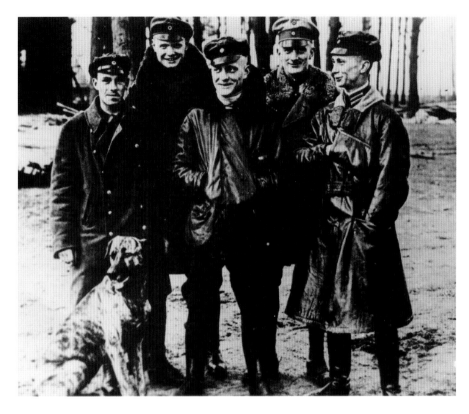

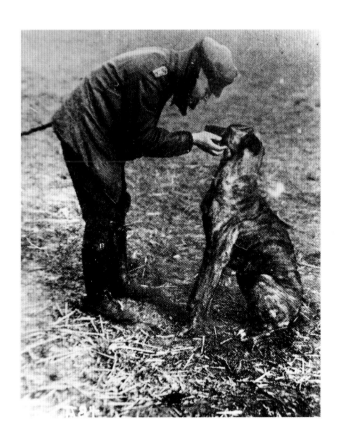

Richthofen thought very highly of Moritz, a Great Dane he had bought as a puppy for five marks: "The most beautiful being in all creation is the genuine Danish hound, my little lap-dog, my Moritz" But Moritz didn't stay a lapdog for long and soon became too large to share Richthofen's cockpit. There may have been other reasons for Moritz's permanent grounding: "Once I even took him with me. He was my first observer... He seemed very interested in everything and looked at the world from above. Only my mechanics were dissatisfied when they had to clean the machine"

In the years before airborne wireless equipment became common and reliable, pigeons provided important messenger service for all of the combatants, carrying dispatches from reconnaissance aircraft, balloons, and front-line troops. Civilian-owned homing pigeons were drafted, and hunters were sternly warned not to shoot at the birds, lest they prevent a vital message from reaching its destination.

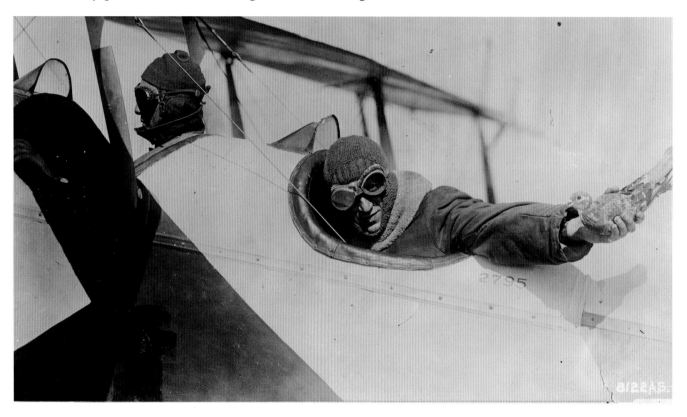

When in uniform, everything, even releasing a pigeon, must be done by the book. The official caption for this U.S. Air Service photograph reads:

> HOLDING PIGEON, *Preparatory to release, the bird must be grasped as to retain its wings and legs and enable the holder to hurl the bird with some force. The adopted method is illustrated herewith.*

The modern reader must sympathize with those Great War pigeons that served in "pigeon hurling" drills; they also serve, who are grasped and hurled

U.S. Air Service photograph.

A German pigeon prepares for takeoff in a Halberstadt CL.IV observation plane.

The bravest of the brave, at least among pigeons, was Cher Ami, a veteran of 12 missions in the American sector of the Verdun front before he was assigned to the 1st Battalion of the 308th Infantry Regiment. During the battle of Meuse-Argonne, Cher Ami became trapped with his unit. On October 3, 1918, surrounded and running out of ammunition and rations, the battalion's commander, Charles Whittlesey, refused the German demand to surrender and launched Cher Ami with a message for headquarters. The Germans spotted the pigeon as he took off and opened fire. Cher Ami made it back to headquarters with his message, though gravely wounded in the breast and leg and blinded in one eye. Known ever after as the Lost Battalion, the exhausted doughboys were relieved a few hours after Cher Ami delivered Major Whittlesey's message. Cher Ami recovered from his wounds, though he lost a leg, and became a hero. He was awarded the *Croix de Guerre* by the French and even met General John J. Pershing, commanding general of the American Expeditionary Force. When Cher Ami died in 1919, he was mounted and displayed in the Smithsonian's National Museum. He can still be visited today in the National Museum of American History.

Smithsonian Institution photograph.

Paul Stockton, commander of the 12th Aero Squadron, compiled a large scrapbook documenting his wartime service, now part of the National Air and Space Museum's collections. He prominently featured his Belgian Malinois dog Marie, also known, as he captioned this photograph, as "Diana de Beausijour, Noted movie star and internationally known Belgian police dog." Stockton claimed that Marie, or Diana, really did have a film career, appearing with Rudolph Valentino and Gloria Swanson. But she seems never to have achieved the fame of another World War I mascot turned actor, Rin Tin Tin – perhaps directors of the day were nervous about working with an armed leading lady. *Photograph by Paul Stockton.*

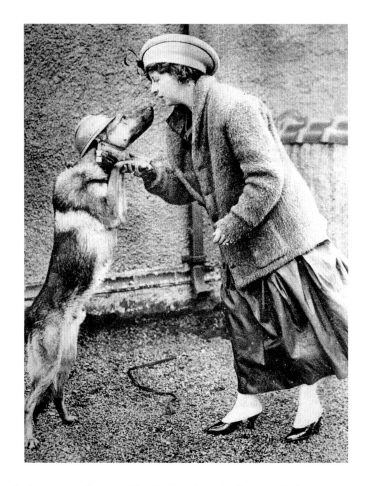

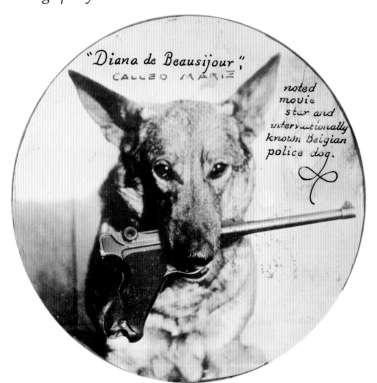

Ruth Law confers with Poilu, her helmeted German shepherd. When America entered the war in 1917, Law, who had learned to fly in 1912, tried to enlist in the Air Service. Rebuffed by the authorities, she traveled overseas to assess military aviation. While in France, Law adopted Poilu, naming him with the nickname of French infantrymen. Back in America, Law and Poilu crisscrossed the country on Liberty Loan and recruitment drives. Ruth Law and Poilu both retired from aviation in 1922 and settled down in Beverly Hills.

Some aviators called the period between the wars a golden age. It was an exciting time to be in the air: the great record flights were made, oceans were spanned by the flying boats and the giant airships, the public was enthralled by air races and barnstormers, and flyers like Charles Lindbergh and Amelia Earhart were famous worldwide. And the opportunities for animal daredevils were pretty good, too.

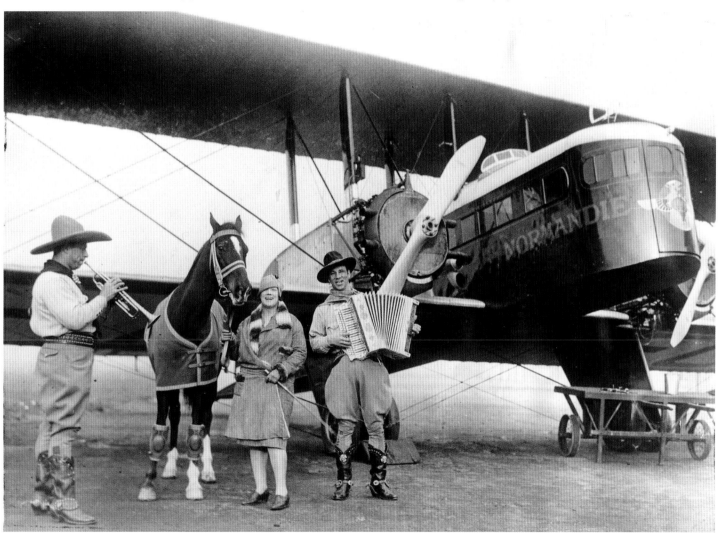

This unidentified horse accompanied Miss Betty Rand and the Hamm brothers from London to Paris aboard the Farman F.60 Goliath *Normandie* in 1922.

Charles Lindbergh traveled solo on his 1927 New York-to-Paris flight in the *Spirit of St. Louis*. But he showed up in a photograph with a dog at least once: Booster the dog poses with Lindbergh (center), "Banty" Rogers (left) and Harold "Cupid" Lynch (right), c.1922. Booster rode on a pad on the turtledeck on Roger's Lincoln-Standard Tourabout.

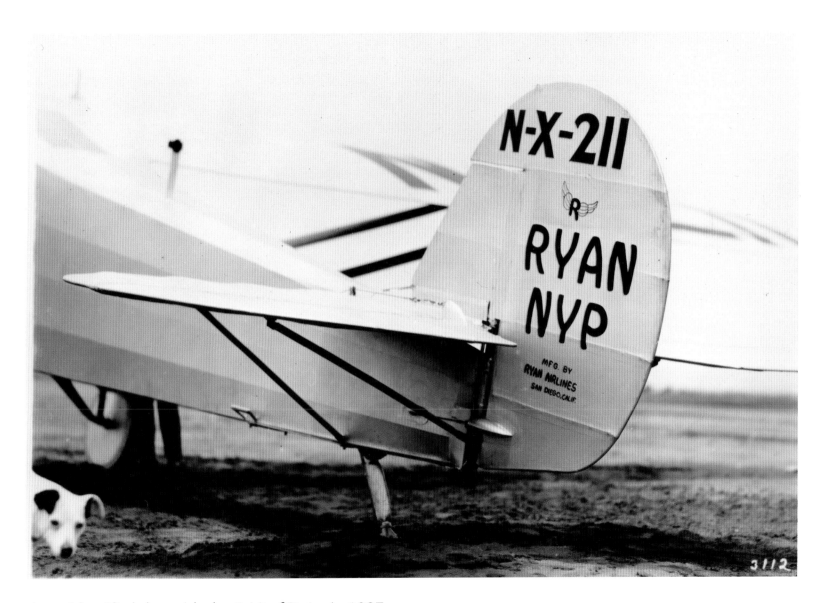

An unidentified dog with the *Spirit of St. Louis*, 1927.

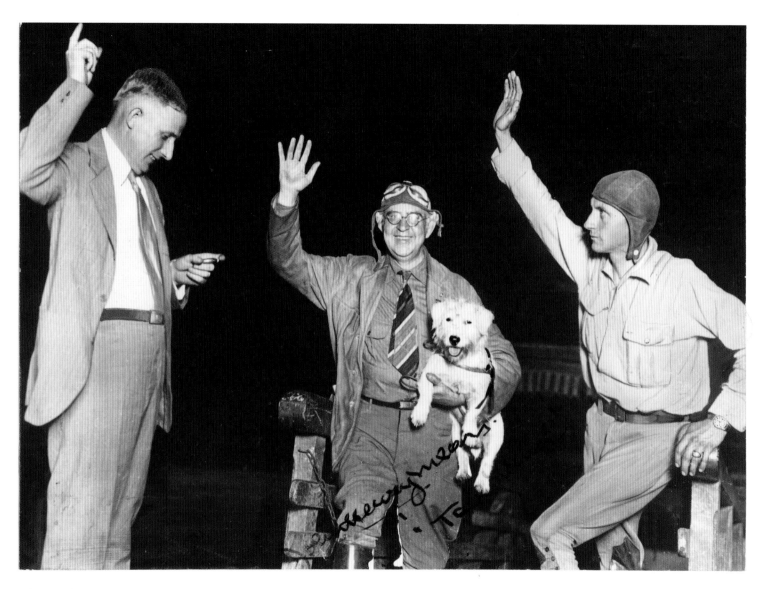

Tail Wind the dog, looking relaxed and confident at the start of a 23-day round-the-world flight in the summer of 1928, is held by John Henry Mears; Charles B. D. Collyer, the pilot, is on the right as A. Shorry of the National Aeronautic Association starts the clock. Tail Wind, Collyer, and Mears made the flight in a Fairchild FC-2W named *The City of New York*. Ocean crossings, however, were made by ship. During the flight legs, they stopped only to refuel, grab a few hours of sleep, and to meet the inevitable posse of dignitaries.

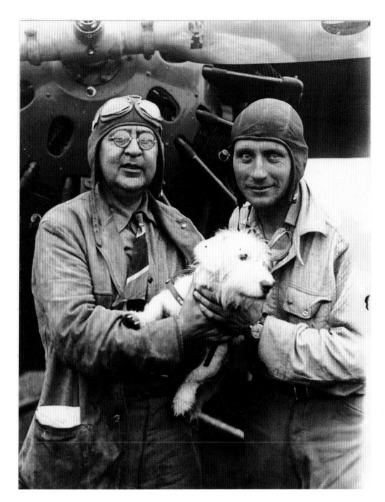

The trip took 23 days, 14 hours, 54 minutes and 25 seconds, and established a new record. Photographs taken during the expedition show an affable Tail Wind meeting and greeting, while Mears and Collyer just look progressively more tired. When Collyer commented, after the trio's return, that Tail Wind "did have the better of the journey in that he had plenty of sleep and an occasional dog biscuit," there seemed to be more than a touch of envy. By the end of the flight, though, everyone, including Tail Wind, looked plain exhausted.

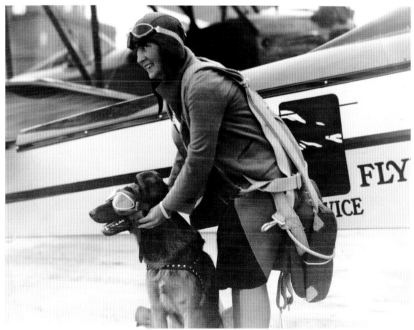

Mrs. Dorothy Claiborne adjusts Bangs' helmet and goggles prior to flight.

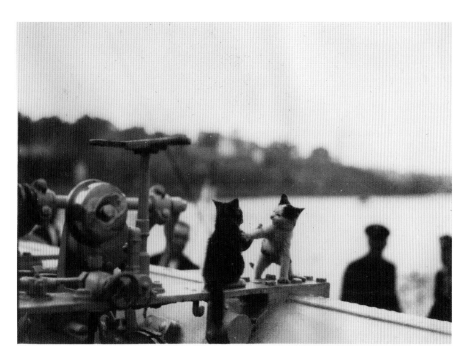

Dogs seem to have been the favored mascots during the Roaring Twenties, but cats occasionally made an appearance. Here, two sea-going kittens duke it out on board the light cruiser USS *Richmond*, 1924.

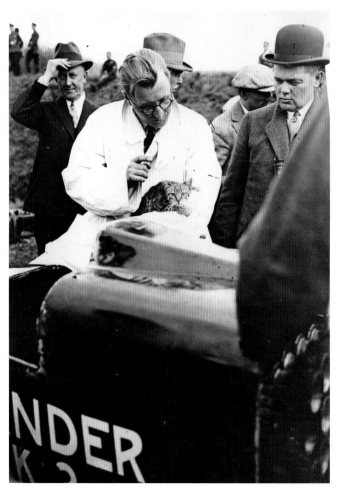

Fritz von Opel's cat took a ride in his Rak 3 rocket car, June 1928, and reached a speed of 290 kilometers per hour (180.2 miles per hour), but does not look pleased.

Some of the finest photographs in the National Air and Space Museum's collection were made by Rudy Arnold (1902-1966) and Hans Groenhoff (1906-1985). Rudy Arnold began to specialize in aviation photography while working on the *New York Graphic* newspaper. In 1928, he began his own business, working out of New York City airports. Arnold's photographs appeared in both aviation and in mass circulation magazines, and in the house publications of the major aircraft manufacturers. He also made movies for Universal and Paramount. Arnold captured an exciting period of aviation history in his pictures, but it wasn't exactly easy work, as he later explained: "All through the early days of flying, I worked as an aerial news photographer, and today I've got the gray hair, scars, and shaky nerves to prove it."

Hans Hermann Hugo Ernst Wilhelm von Groenhoff was born in Germany and immigrated to the United States in 1927. In 1932, Groenhoff's photographic career began when he inherited two cameras from his brother Günther, a distinguished glider pilot. He honed his skills photographing at New York area airports and air meets, and by 1937, his byline began to appear in aviation publications with increasing frequency. Later, magazines like *Life, Time, Collier's*, and *National Geographic* all ran Groenhoff photographs. His aviation photographs were noted for their striking compositions and elegant arrangements of aircraft and clouds. As America prepared for and then entered World War II, Groenhoff documented the massive buildup of the "Arsenal of Democracy." Viewed today, Groenhoff's color images have a freshness and immediacy that defies nostalgia.

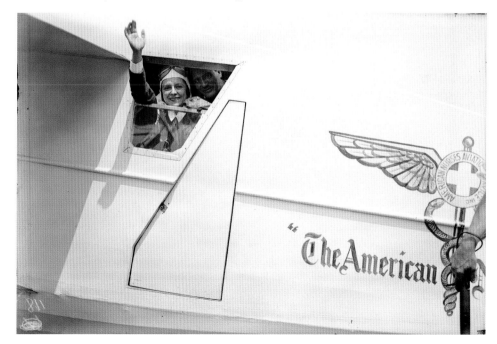

Edna Newcomer, holding Tailwind the woodchuck, waves from the cabin of the Bellanca Skyrocket *The American Nurse*, at Floyd Bennett Field, New York, September 1932. Dr. Leon Pisculli, also seen in the window, organized the nonstop New York-to-Rome flight to study the effects of long-distance flight on humans, and presumably, on woodchucks. But *The American Nurse* went missing, and Newcomer, Pisculli, pilot William Ulbrich, and Tailwind the woodchuck were never seen again. *Photograph by Rudy Arnold.*

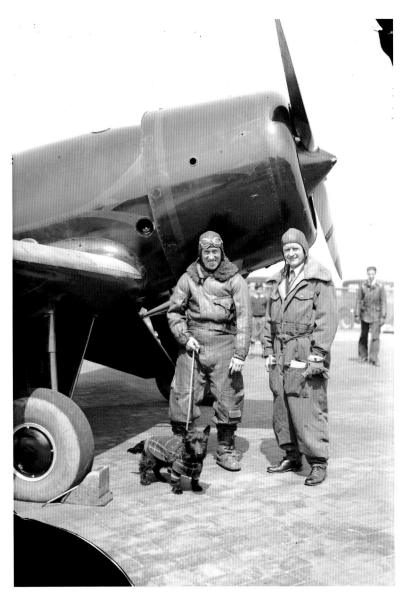

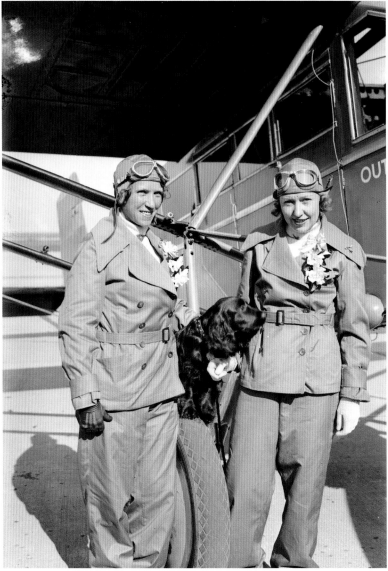

Frank Hawks (left) with James Wheeler and a friend in tartan, next to a Lockheed Explorer. Floyd Bennett Field, 1934.
Photograph by Rudy Arnold.

Viola Gentry with cocker spaniel and Mary Sansom, next to their Curtiss Thrush J *Outdoor Girl.*
Photograph by Rudy Arnold.

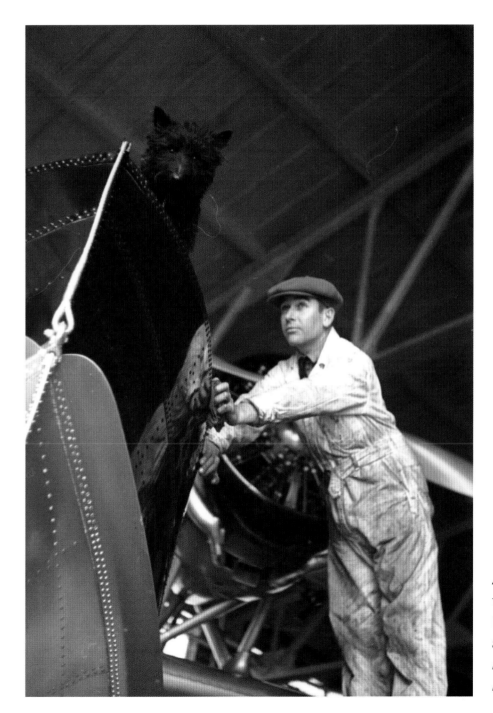

A Scottish terrier peers
from the bow of a
Douglas Dolphin
amphibian, c.1938.
*Photograph by
Hans Groenhoff.*

51

A Yackey Transport BRL-12 gets a tow on a rural airstrip, c.1926.

Searching for the wreckage of *Yankee Doodle*, a Lockheed Vega piloted by Charles Collyer, near Palace Station, Arizona, November 1928. Collyer and the plane's owner, Harry J. Tucker, were both killed.

Photograph by Bate Prescott.

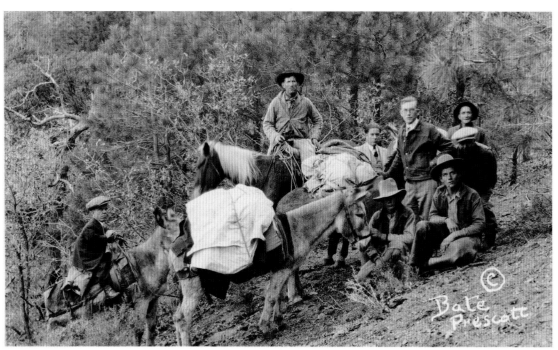

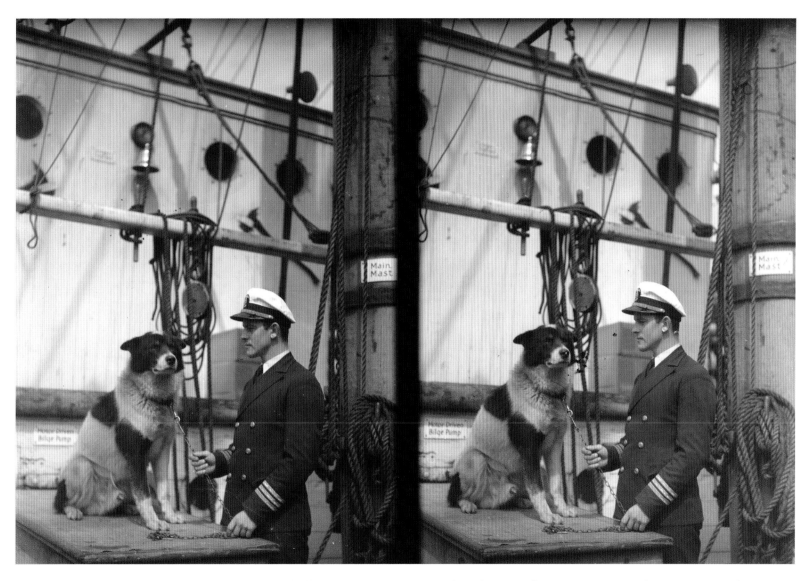

A stereoview photograph of a veteran sled dog on Captain Richard E. Byrd's Antarctic exploration vessel, *The City of New York*, 1935. The ship was docked in Cleveland, Ohio, at the time, far from the South Pole.

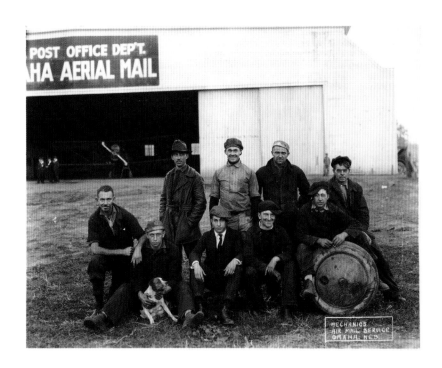

Air mail mechanics and their mascot, Fort Crook Air Field, Omaha, Nebraska, c.1928.
Photograph by Nathaniel L. Dewell.

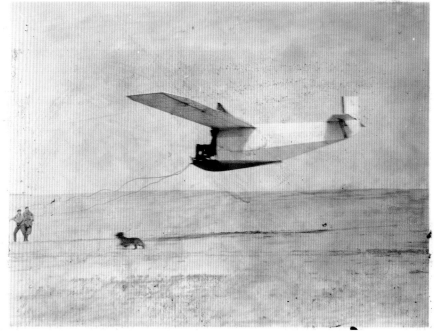

Some dogs just can't be satisfied with chasing cars; glider chasing, in this case a Zingo Intermediate Glider, makes an exciting change.

Movie cowboy Ken Maynard, star of *The Fiddling Buckaroo*, introduces his horse Tarzan to his Travel Air 4000.
Photograph by Edgar B. Smith.

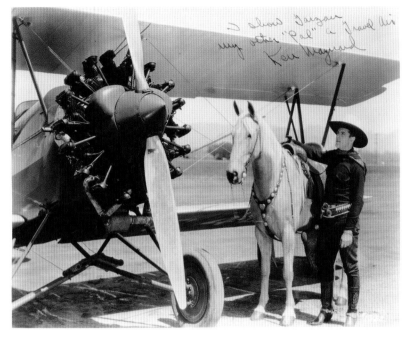

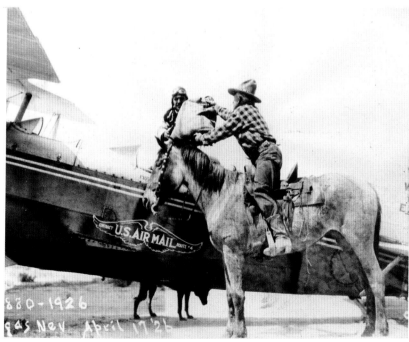

A cowboy delivers the mail to the pilot of a Western Air Express Douglas M-2 Mailplane, Las Vegas, Nevada.

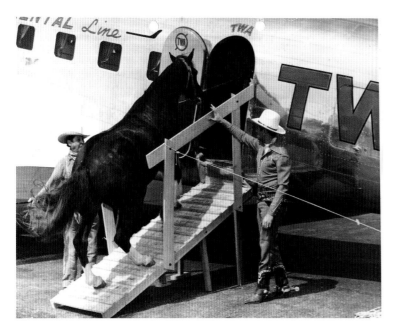

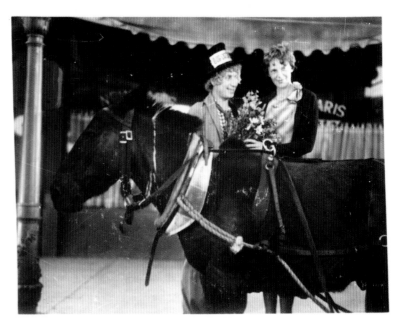

With the coming of safe and reliable air transport, trail drives became a bit less arduous for both man and beast. Gene Autry watches as Champion boards a Transcontinental & Western Air Douglas DC-2, Burbank, California, 1940.

Amelia Earhart meets Harpo Marx on the set of *Horsefeathers*, 1932.

Smoke balloons used to be a popular attraction – crowds watched as intrepid aeronauts were lofted high on a hot air balloon, like the one in the background here. There would be a display of aerial acrobatics, and then the performer would parachute gracefully back to earth. A balloonist with the Johnny Mack balloon show prepares a small dog-sized parachute while the dog's mistress looks on dubiously – the dog looks confident enough, though.

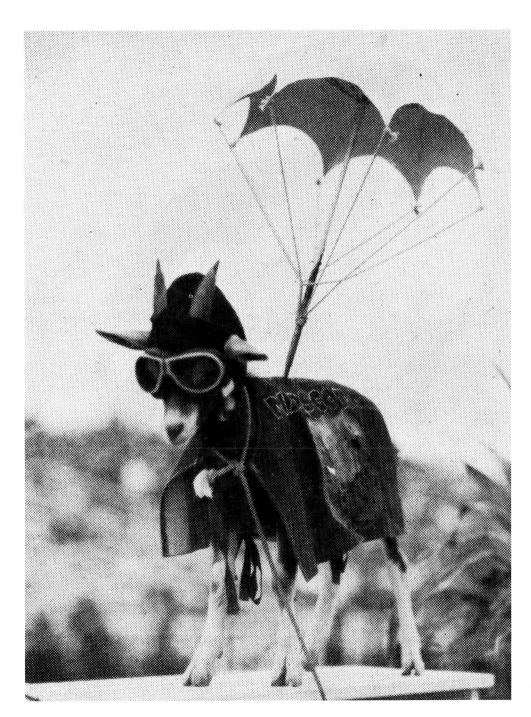

Bill the Goat, U.S. Navy Mascot, at the
National Air Races, Los Angeles, 1933. 57

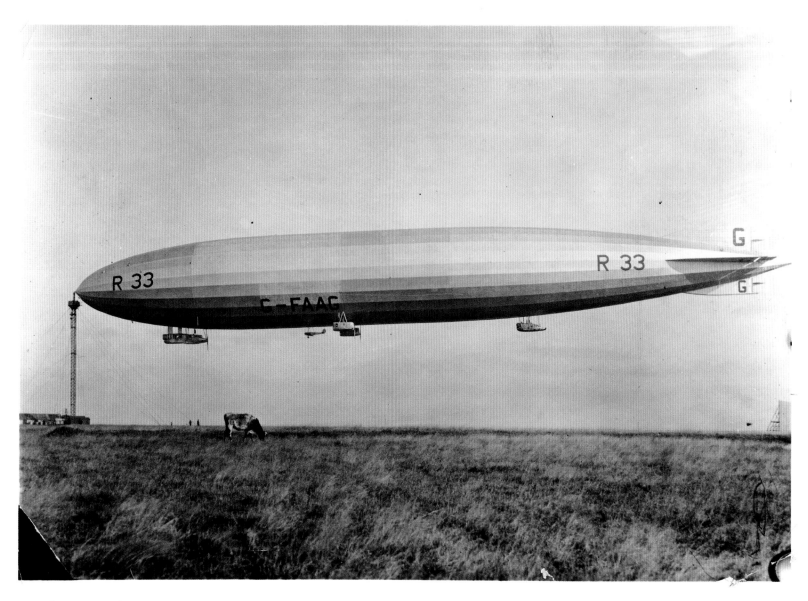

Landscape with cow and airship – the British rigid airship R 33, Pulham Airship Station, Norfolk, England, 1925.

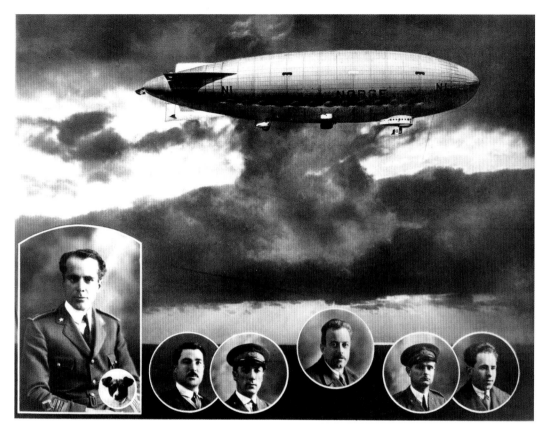

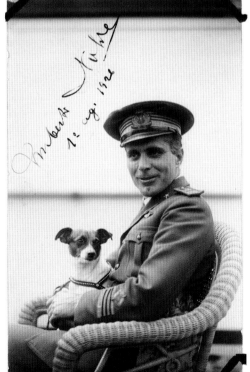

General Umberto Nobile and Titina, after the *Norge* flight, August 1926.

When Umberto Nobile (1885-1978), a leading airship designer and pilot, flew with Roald Amundsen to the North Pole in the airship *Norge* in 1926, he took his fox terrier Titina along for the ride. In 1928, Nobile commanded the *Italia* in another flight to the Pole, again accompanied by Titina. The *Italia* crashed after they over flew the North Pole, and Nobile, Titina, and eight other survivors were left stranded on the ice. When several of the crew left to find assistance, Nobile mentioned the dog in a note to his daughter: "Titina is perfectly happy here, but perhaps she would still rather be at home … ." Nobile, Titina, and the other crewmen had a harrowing time of it, but after a month, all were rescued.

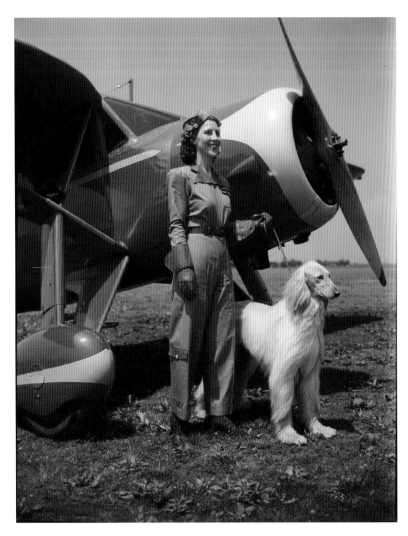

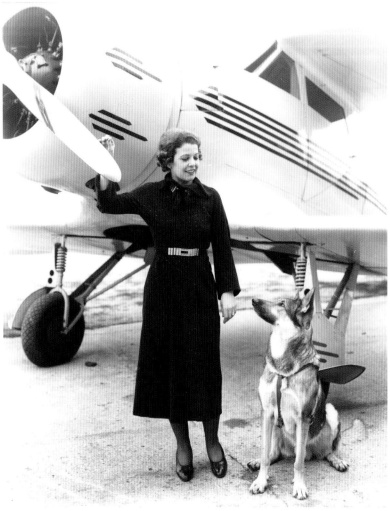

An unidentified lady in a rather elegant turnout with her Fairchild 24W and Russian wolfhound, c.1938. *Photograph by Hans Groenhoff.*

Mrs. Arlene Davis and German shepherd with a Beech B17L Staggerwing, 1935.

The Flying Bowmans of Dallas, Texas – Father Les, mother Marguerite "Martie," and daughter Lorraine "Larnie" all flew. Les worked for the Kinner Engine and Aircraft Company in production and testing. Martie was a member of the 99s, a women pilots' association, and the National Air Race Association, and was a highly successful air racer. Larnie, known as "The Flying Texanita," learned to fly by the time she was 12 years old. The whole family also gave wing-walking a try – Larnie starting at the age of 8. The Bowman pets also flew, but the Bowman Family Papers don't reveal if they also tried wing-walking.

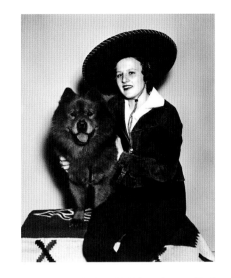

Larnie Bowman with her chow Tillicum, 1937.
Bowman Family Papers.

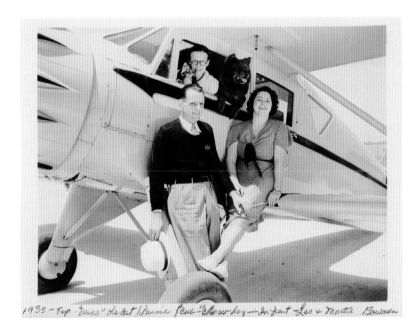

Les and Martie Bowman stand in front of their Waco UIC cabin biplane. Sitting in the cockpit are Larnie Bowman with Waco the cat and Cub the Chow dog, 1933.
Bowman Family Papers.

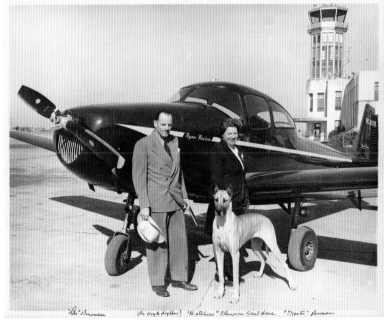

Les and Martie Bowman with Duchess the Great Dane in front of their Ryan Navion NAV-4, c.1948.
Bowman Family Papers.

Roscoe and Gilmore

Roscoe Turner (1895-1970), winner of the Bendix Trophy and three-time winner of the Thompson Trophy, was a memorable figure of the Golden Age of Aviation. Turner cultivated a dashing air with his waxed mustache, custom-made uniform, and diamond-encrusted flying wings insignia. In 1930, Turner was flying for the Gilmore Oil Company, which used a lion's head as a trademark. Thinking that a real lion would help generate publicity, Turner adopted a 3-week-old cub and promptly named him Gilmore. The cub was an instant hit with the public, and Gilmore became the most famous lion of the 1930s.

Gilmore didn't immediately take to the idea of flight. After his first flight, Roscoe told the story: "He was a pretty tired and nervous little cub when it was over. He was all right until we began to take off, but the minute the plane left the ground he made one terrified dive for Mrs. Turner's lap and stayed there. It was weeks before he stopped trying to scramble in someone's lap when we took off. The Humane Society raised fears of Gilmore's safety, so Turner had a cub-sized parachute and harness made for him. Gilmore, wearing his chute, poses with Roscoe Turner beside Turner's Lockheed Air Express 3.

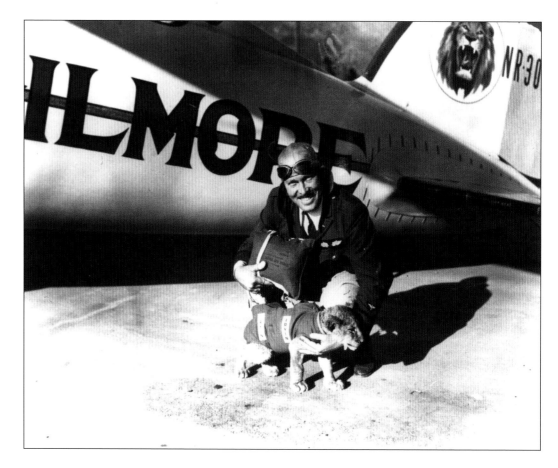

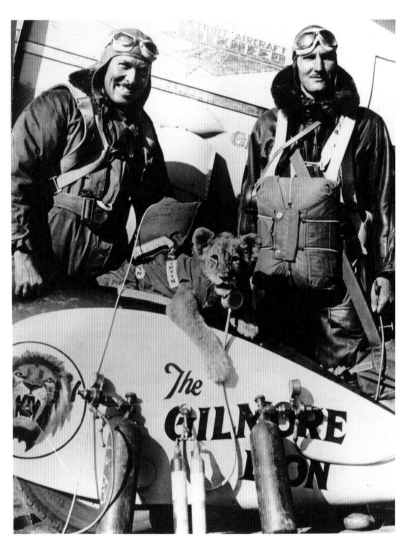

Roscoe Turner (left), Gilmore, and Turner's mechanic, Don Young.

Gilmore logged over 25,000 miles in the air with Roscoe. He became a confident flyer, but in rough weather still preferred to curl up in Roscoe's lap.

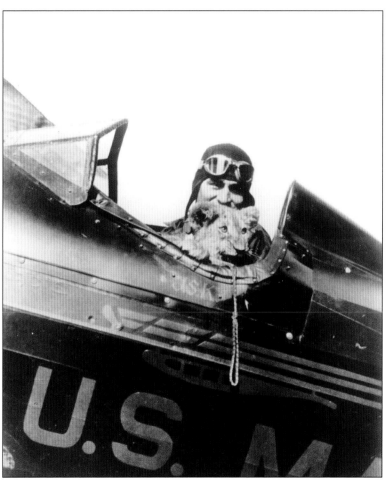

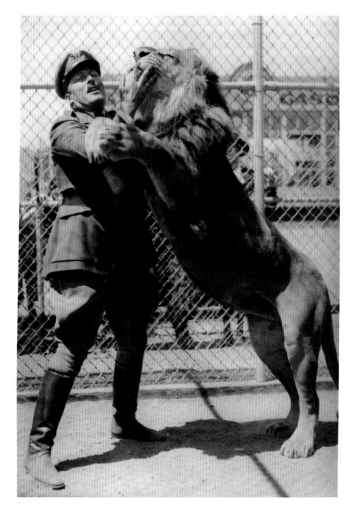

Gilmore soon got too big for Roscoe's lap and was finally grounded when he reached 150 pounds, retiring at first to the Turner home in Beverly Hills. He was popular at parties, but made the mailman nervous and tended to cause other golfers to panic when he followed Roscoe around the golf course. In 1940, Gilmore finally retired to a wildlife park, with Roscoe footing the hefty food bills. "For a long time he paid my bills; now it's my turn," Roscoe said.

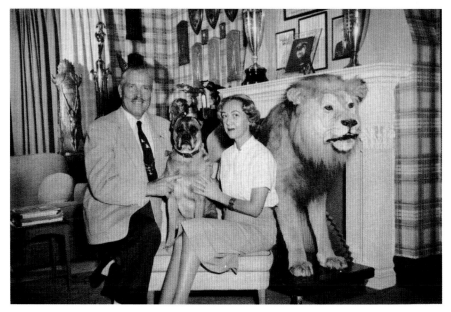

Roscoe Turner, Penny the boxer, Madonna Turner, and Gilmore. Gilmore died in 1952 at the age of 22. Preserved by a taxidermist, he remained in the Turners' Indianapolis den until Roscoe's death in 1970.

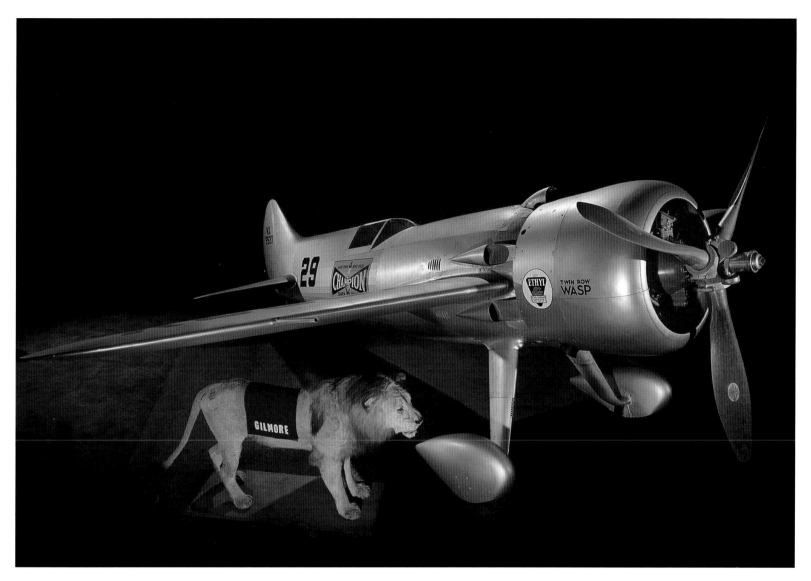

Gilmore with Roscoe Turner's Turner-Laird RT-14 *Pesco Special* racer, National Air and Space Museum. After Roscoe's death, Gilmore was donated to the Museum, where he was exhibited for many years. At the time of writing, Gilmore resides in cold storage, but there are plans to spruce him up and put him on display once again at the Museum's Steven F. Udvar-Hazy Center.

Photograph by Eric Long.

With the outbreak of World War II, animals once again flocked to the colors. Mascots served in all branches and on all fronts: pigeons were still used for communications, and mules carried supplies where trucks and jeeps couldn't go.

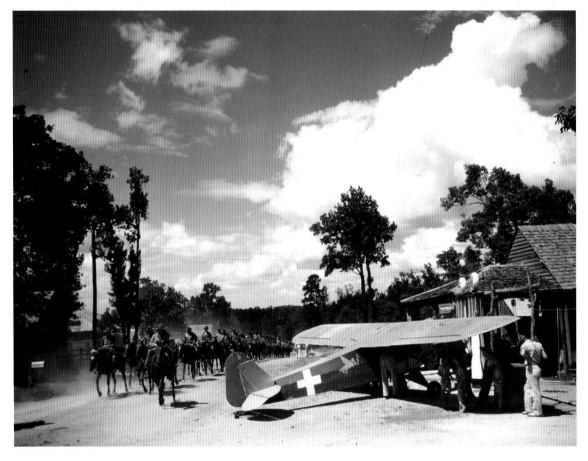

A cavalry column marches past a Piper J-3C Cub during the 1941 Louisiana Maneuvers. In order to demonstrate their usefulness to the Army's brass, several aircraft manufacturers loaned light civilian planes, piloted by civilian volunteers, to the U.S. Army Air Corps. The white cross on the Cub's side marks the aircraft as a member of the "White Force." The little planes were nicknamed "grasshoppers" and proudly sported the insect as their personal insignia.
Photograph by Hans Groenhoff.

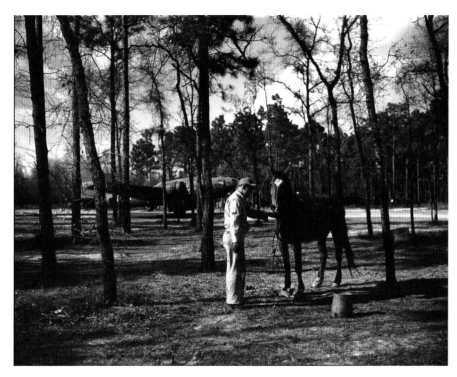

An airman tends a horse at the edge of an unidentified stateside airstrip, a Boeing B-17G Flying Fortress in the background, c.1943. *Photograph by Hans Groenhoff.*

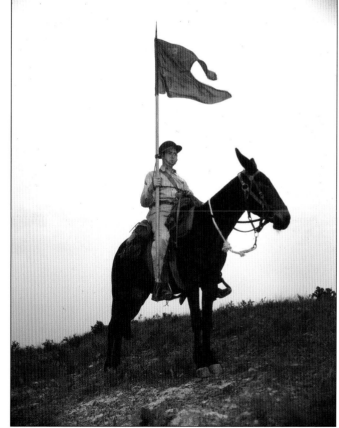

Pfc. Winford Mauk of the U.S. Army Field Artillery carries his battery's guidon on muleback, 1942. *Photograph by Rudy Arnold.*

Mascots tended to have their
pictures taken in all sorts of
interesting situations ...

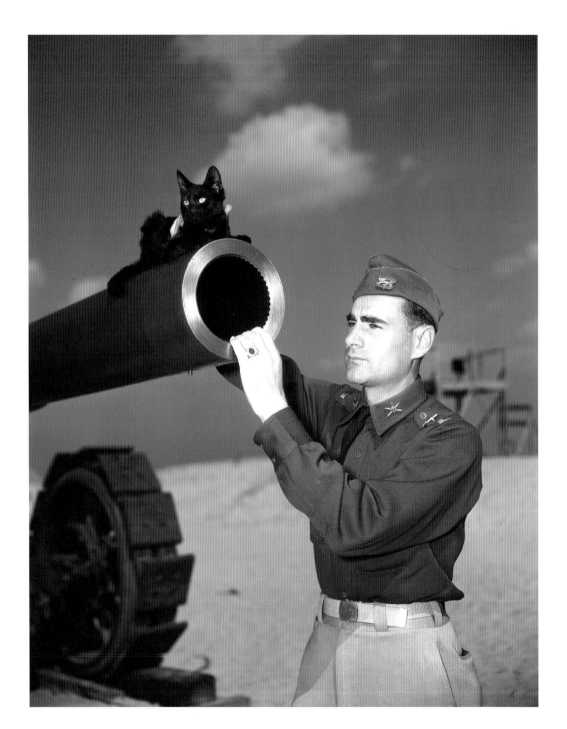

A cat with her own 155mm
artillery piece – possibly a dog's
worst nightmare. Tillie, mascot of
an Army Coast Artillery unit, with
1st Lt. C. A. Gross, 1941.

Photograph by Rudy Arnold

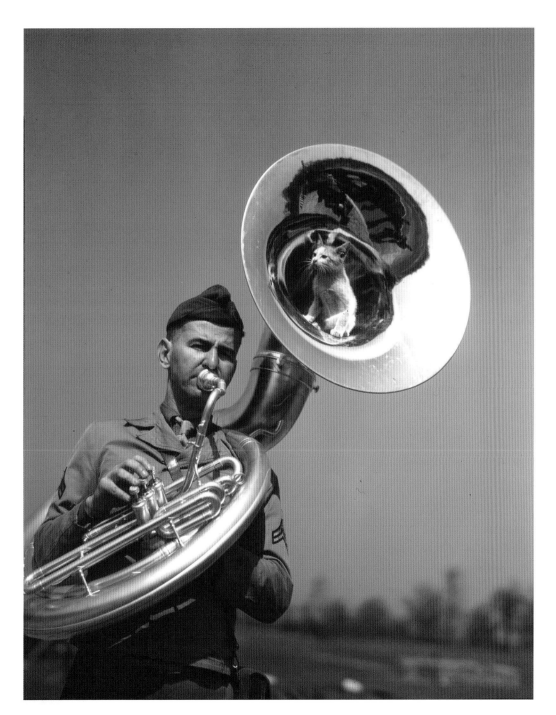

Misfire the kitten gets an earful
from Corporal Manuel Campos
on the sousaphone, Fort Totten,
New York, 1942.
Photograph by Rudy Arnold

69

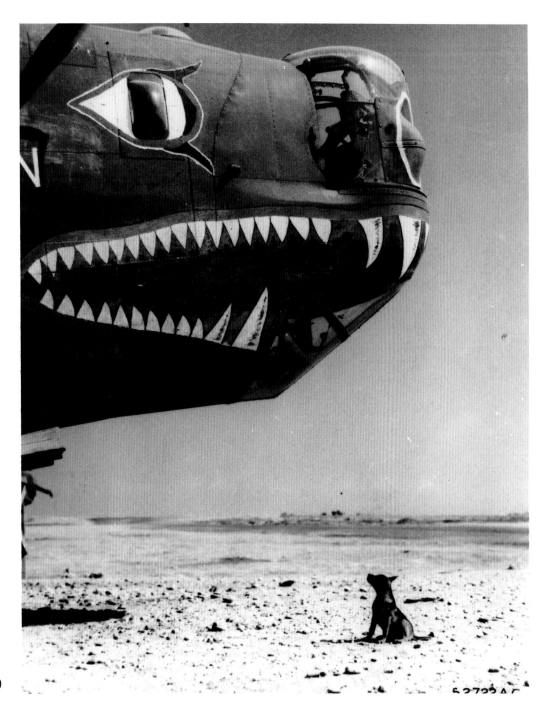

Frank, mascot to a bomb group of the Fifteenth Air Force, gazes at the nose of the Consolidated B-24 Liberator *Howling Wolf*, Italy, 1944.

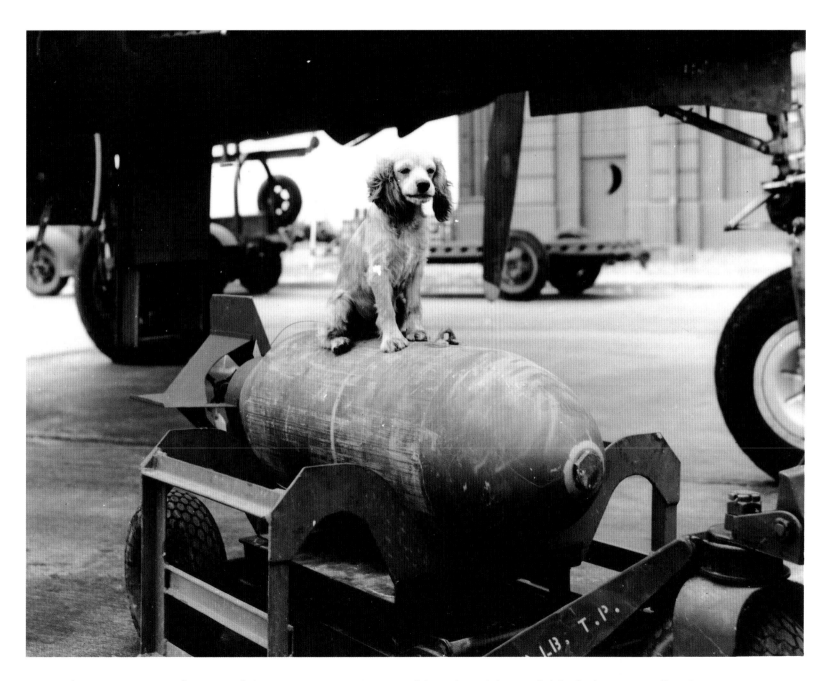

An ordnance crew cocker spaniel poses on a 500-pound bomb, Hickam Field, Oahu, Hawaii, 1945.

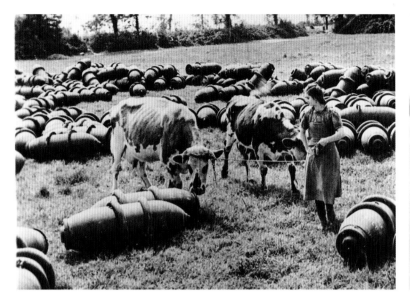

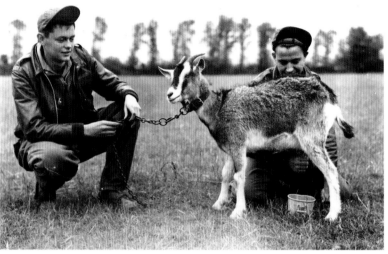

The original caption says that "the combination of bombs and bovines is typical of this war that leaves nothing untouched." An RAF bomb dump shares space with a cow pasture in Normandy, August 1944.

Fresh milk for the troops from Lu the goat on an Eighth Air Force base in England. Staff Sgt. Roy D. Crozier, a B-17 ball turret gunner, does the milking while Tech Sgt. George Treece, a radio operator, watches. 1943.

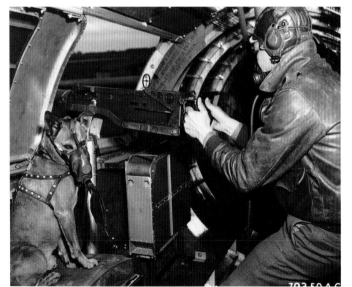

Mister scans the skies, high over Germany – he barks a warning through his throat mike! "What is it, boy? Bandit at 3 o'clock? Good boy!" Mister, the mascot of Staff Sgt. Harold E. Rogers, a B-17 waist gunner, saves the day again. Mister had flown five missions when this 1943 U.S. Army Air Forces photograph was taken.

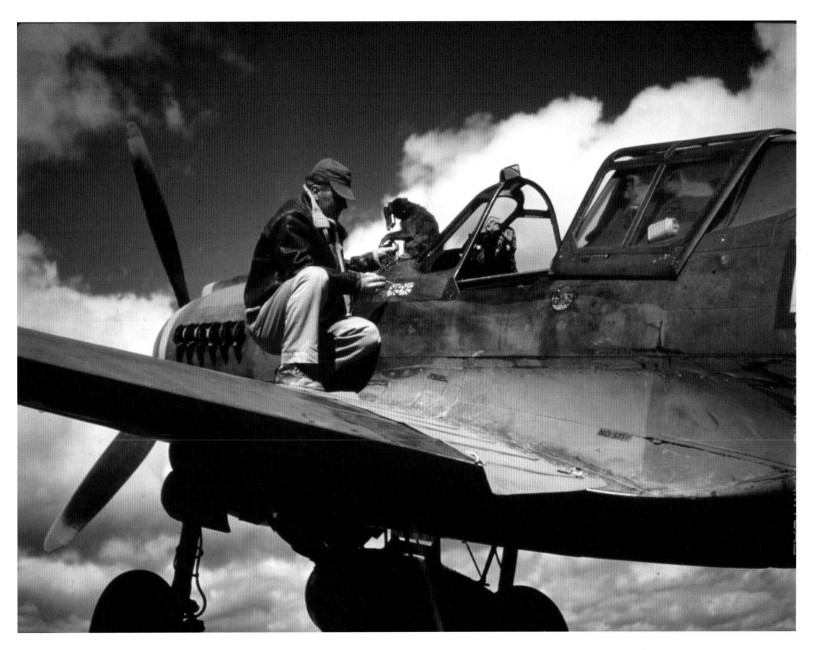

Assisted by his monkey, Sgt. Elmer J. Pence of the 51st Fighter Group paints a victory marking on Major Edward Nollmeyer's P-40K Warhawk, somewhere in China, 1943.

Certain mascot photo opportunities seem to have been universal ...

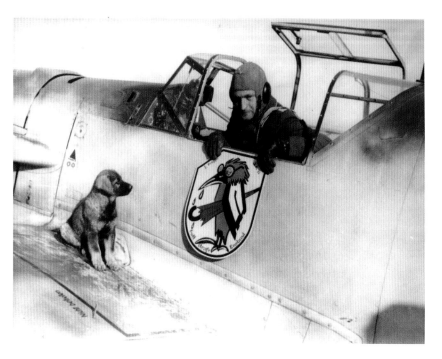

A pilot in his Messerschmitt Bf 109E and a mascot of *Jagdgeschwader* (Fighter Squadron) 51 admires the unit's badge, 1940.

A pilot of the RAF Eagle Squadron (No. 71 Squadron) in a Hawker Hurricane II bids farewell to his dog before takeoff, c.1941.

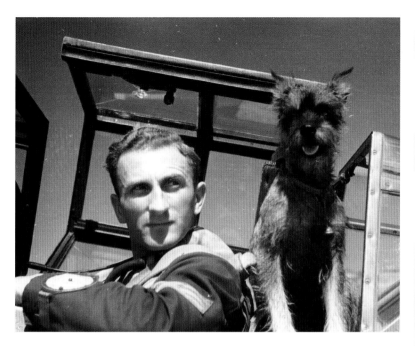

There's slightly more room for another Luftwaffe mascot in the cockpit of a Junkers Ju 52 transport aircraft.

The Messerschmitt Bf 109E may have been one of the outstanding fighter planes of World War II, but its cramped cockpit was a serious drawback as far as the squadron mascot was concerned. Except in emergencies, the canopy couldn't be opened in flight, so how could the faithful *staffelhund* stick his head out of the window during joyrides?

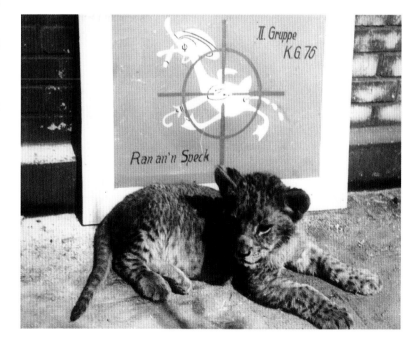

A Luftwaffe bomber squadron's lion cub mascot. Possibly a descendant of the Lafayette Escadrille's Whiskey and Soda?

Toughy, Huffy, and Snuffy, mascots of a British tanker ship, take over a diver's helmet at a Brooklyn shipyard, 1944.

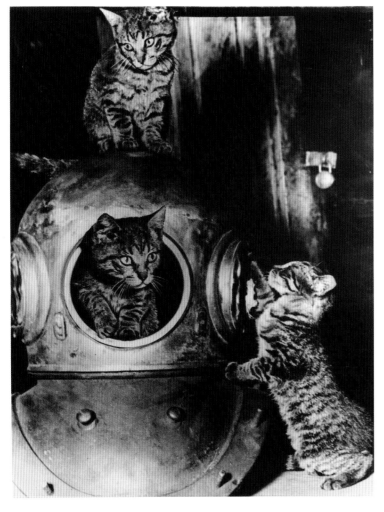

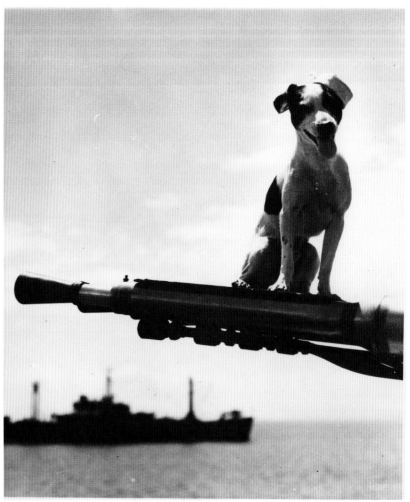

Kelly, seen here sitting on an antiaircraft gun, was literally born to the sea – on a Coast Guard cutter in the middle of the Atlantic, as a matter of fact. Transferred to the Pacific, he served at Saipan and made it up the ranks to Gunner's Mate, 2nd class.

Dr. William Rigby Jacobs (1906-1957) was a U.S. Army Air Forces flight surgeon serving with an Arctic Search and Rescue Unit attached to the Alaskan Wing of the Air Transport Command. Jacobs' unit, along with a team of sled dogs, would parachute into the Canadian and Alaskan wilderness to rescue downed pilots. This page from Jacobs' scrapbook, now part of the Museum's collections, shows some of his furry colleagues from the rescue unit, c.1944.

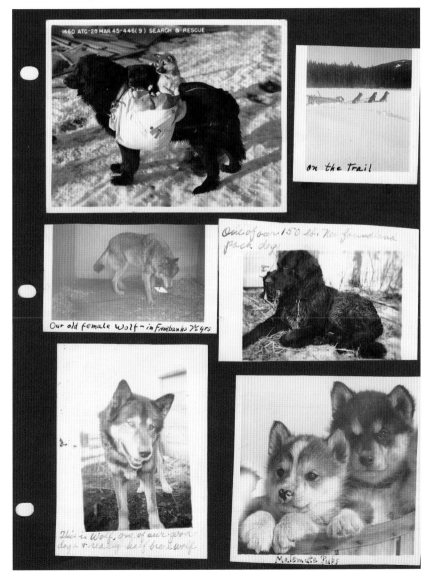

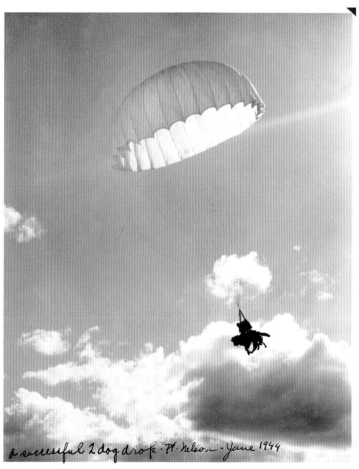

Sled dogs Maggie and Jiggs make their first parachute jump, Ft. Nelson, British Columbia, Canada. June 1944.
William Rigby Jacobs Collection.

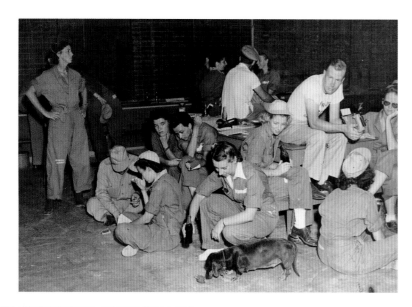

WASP (Women Airforce Service Pilots) student pilots, flying instructors, and a dachshund wait for orders in the flight ready room, Avenger Field, Sweetwater, Texas, c.1943.

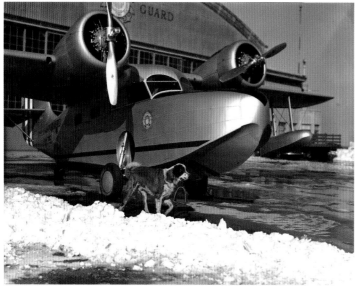

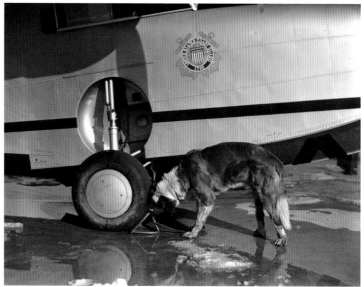

Merely fetching the master's newspaper or slippers just doesn't do it for some dogs. Bruno, a Coast Guard St. Bernard, fetches wheel chocks for a Grumman JRF-2 Goose amphibian ...

... And makes sure the chocks are securely positioned – what a good dog!
Photographs by Rudy Arnold.

As America prepared for war, the nation's pigeons were also mobilized. Photographer Hans Groenhoff visited the U.S. Army Signal Corps' 280th Signal Company, soon to be renamed the 280th Pigeon Company, at Camp Claiborne, Louisiana and snapped the pigeons and pigeoneers.

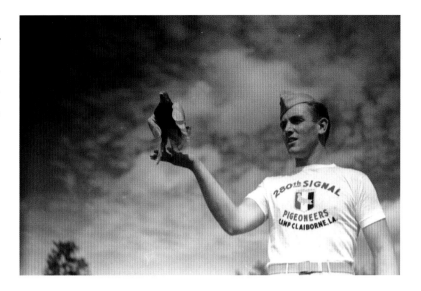

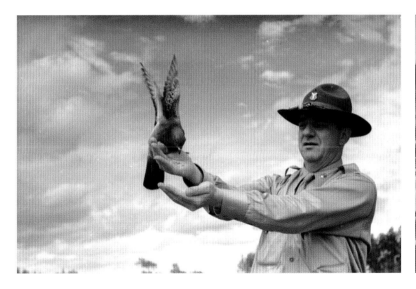

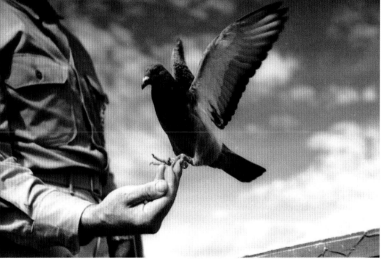

In 1941, the Army's Pigeon Training Center at Fort Monmouth, New Jersey, experimented with hawks for intercepting enemy pigeons. A zoo donated three volunteers for the program: a red-tailed hawk, a sparrow hawk, and a prairie hawk named Maizie. No information, though, on whether or not Maizie and her comrades ever saw combat.

Joseph J. Pace was the chief of a photographic section at a USAAF base in Malir, India (now Pakistan), near Karachi. Pace photographed aircraft and equipment and documented operations and training activities at the headquarters. On July 4, 1945, he also snapped the first – and possibly the only – rodeo held in Malir.

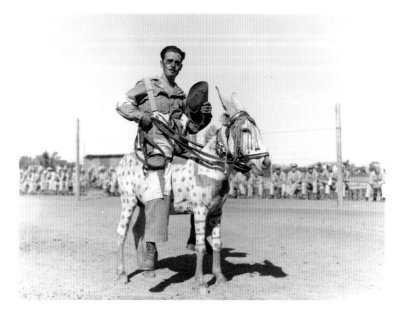

In later years, when this airman was asked by his children what he did in the war, did he admit that he served as a rodeo clown?

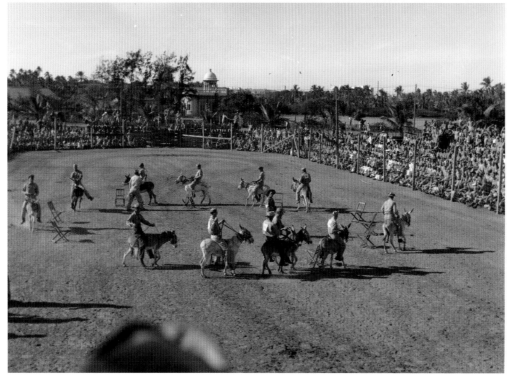

A fast-paced game of donkey-mounted musical chairs.

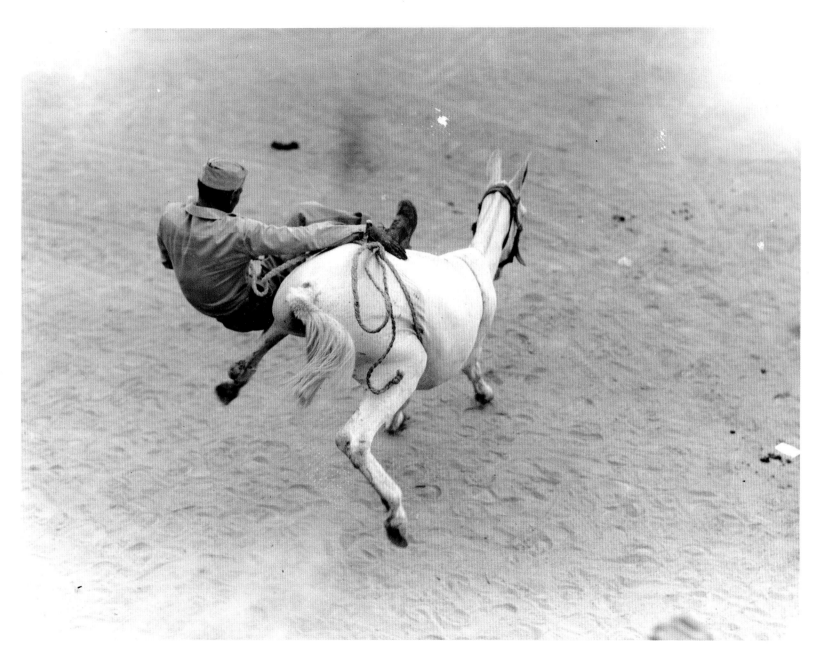

A bucking mule sends its airman rider airborne.

Civilian aviation expanded tremendously with the end of the war. Once again, flying hunting trips were possible, or you could make flying visits to check on your polo ponies.

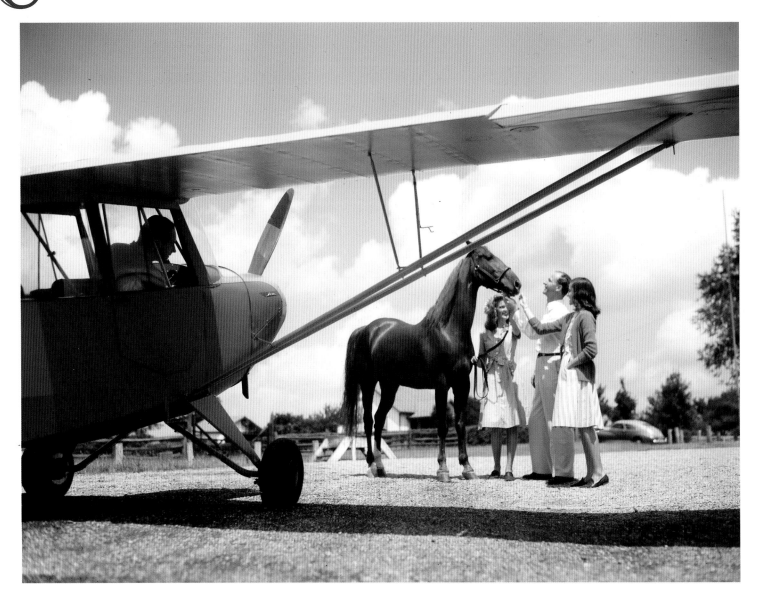

An Aeronca 7AC Champion visits the horse farm. *Photograph by Hans Groenhoff.*

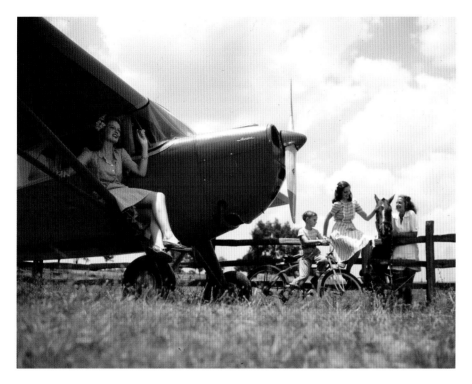

A young lady relaxes on an Aeronca Model 11AC Chief in another photograph by Hans Groenhoff.

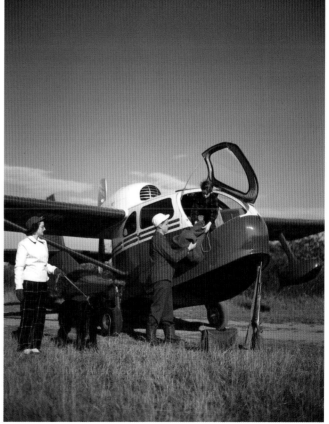

The family dog stands by while a Republic RC-3 Seabee amphibian is packed for a hunting trip. *Photograph by Rudy Arnold.*

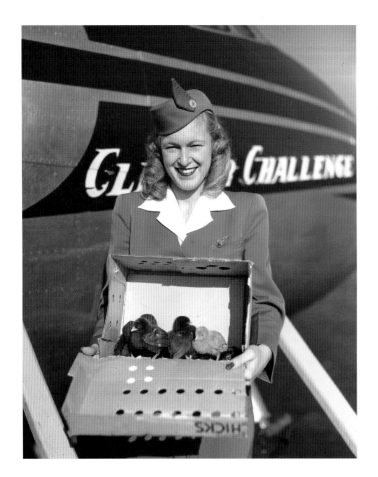

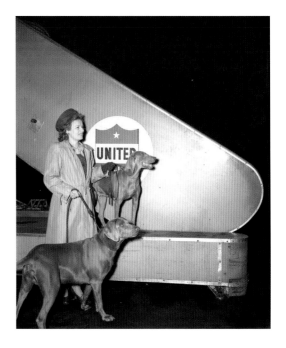

Following a dog show, Mrs. Yvonne Goldsmith pauses by the passenger stairs with her two Weimaraners before the dogs are loaded for their flight back to San Francisco. *Photograph by Rudy Arnold.*

A Pan American Airways stewardess with a box of gaily-colored Easter chicks in front of Pan Am's Lockheed Constellation *Clipper Challenge*. *Photograph by Rudy Arnold.*

Rudy Arnold captured this group of executives bidding farewell to a herd of Guernsey calves about to depart from La Guardia Airport, New York City, for Colombia on an International Air Freight Douglas DC-3A, May 1946.

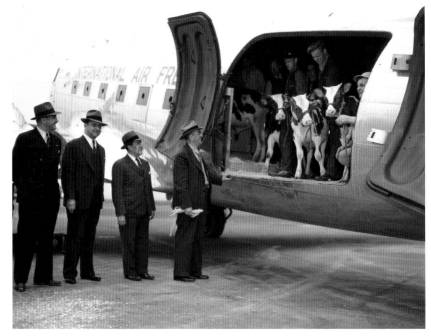

Curiously, a large percentage of pictures of the Fulton FA-2 Airphibian roadable monoplane include dogs or horses. Even so, the Airphibian series, designed by Robert Fulton, Jr. and built between 1945 and 1953 for use on both the airways and highways, never really took off, so to speak, with the public.

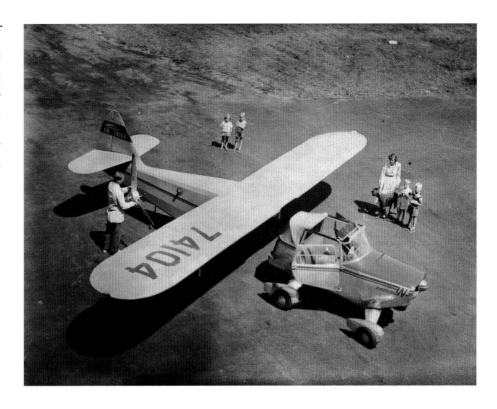

The complete Fulton Airphibian consisted of a road unit and flight unit. Company brochures demonstrated the ease with which the units could be joined by showing a lady in heels deftly attaching the propeller with a built-in wrench.

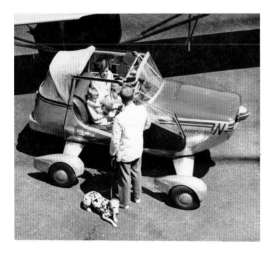 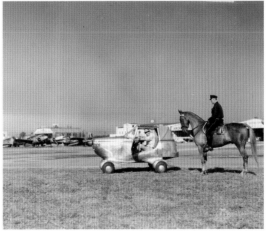 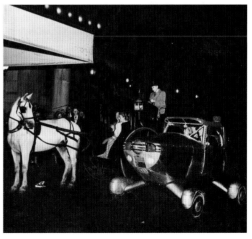

The Airphibian was perfect for a night on the town, as long as it didn't scare the horses. Fulton's son Robert recalled that "Anytime you showed up in an Airphibian, it was a media event."

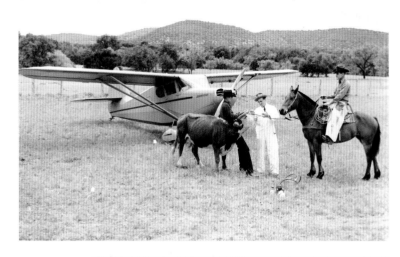

A flying vet administers a dose to a cow; in the background is his Stinson Voyager 10-A. *Photograph by James F. Laughead.*

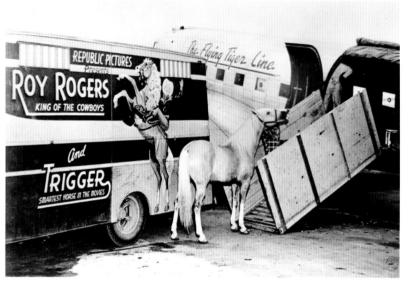

Trigger, Roy Rogers' faithful palomino, prepares to board a Flying Tigers Line Douglas DC-3. Trigger, billed as "the smartest horse in the movies," first appeared as Olivia de Havilland's mount in the 1938 *Adventures of Robin Hood* and went on to stardom in dozens of movies, including *My Pal Trigger, The Golden Stallion,* and *Heldorado.* He usually got second billing, after Roy – and above that of Roy's co-star, Dale Evans.

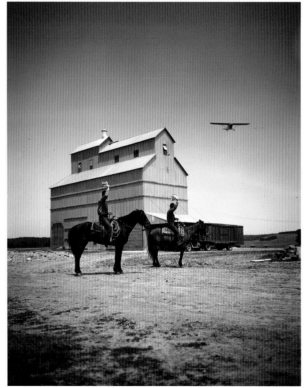

Cowboys wave to a Piper PA-12 Super Cruiser. The number of different takes in the Museum's files made by photographer Hans Groenhoff suggests that the cowboys were waving, and the aircraft was circling, for a very long time ...

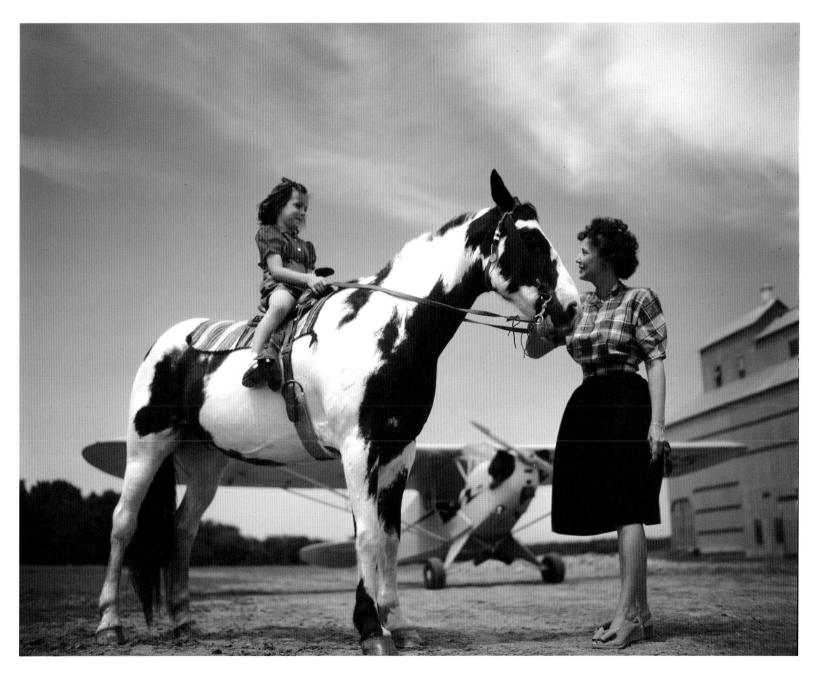

A little girl on a pinto pony, and a Piper J-3C Cub – another elegant Hans Groenhoff composition.

pace may be the final frontier, but cosmonauts and astronauts were preceded into space by the animals – tragically, some of them made the ultimate sacrifice.

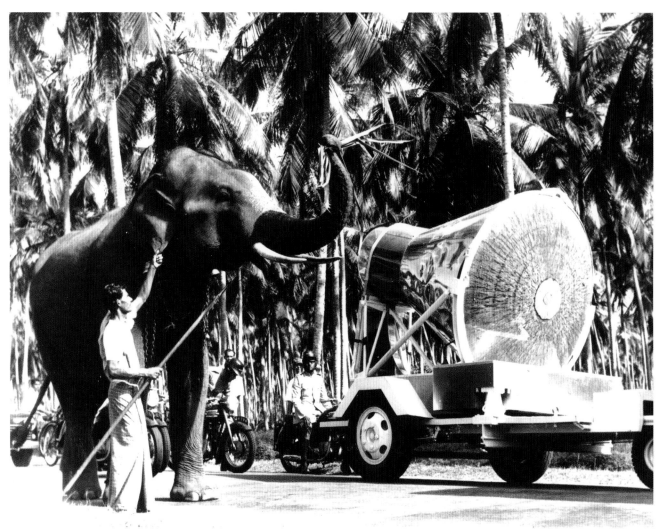

An elephant salutes the Mercury capsule *Friendship 7* at Katunayake Airport, Ceylon (now Sri Lanka), following a three-day exhibition in Colombo in July 1962. On February 20, 1962, John Glenn aboard Friendship 7 became the first American to orbit Earth. The *Friendship 7* capsule is now on display in the National Air and Space Museum.

Jules Verne imagined the effect of zero gravity on his space voyagers – three men, two chickens, and a dog – in Round the Moon (1873), the sequel to *From the Earth to the Moon.*

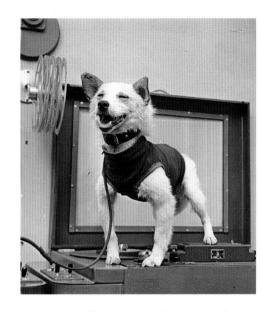

Belka ("Squirrel") had a happier flight than Laika's. Along with Strelka ("Little Arrow"), 40 mice and two rats, Belka flew 17 orbits on board Sputnik 5 on August 19, 1960 – they were the first animals to survive orbital flight. Strelka later gave birth to six puppies, one of which was given to President John F. Kennedy's daughter Caroline. Looking a bit relieved, Belka is seen here after the flight.
Photograph by Y. Abramochkin. Herbert Stephen Desind Collection.

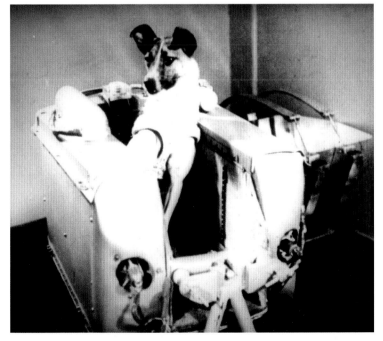

Laika – the name means "Barker" in Russian – sits in her capsule prior to the launch of *Sputnik 2.* Originally named Kudryavka ("Little Curly"), Laika was a true space pioneer; the first living creature to travel in Earth orbit. Alas, it was a one-way mission; there was no way for Laika to return to Earth. Launched on November 3, 1957, Laika died, probably from heat stress, four days later. Laika is commemorated on the cosmonaut monument at Star City, near Moscow – her image, ears erect, can be seen peeking out from behind the figures of the cosmonauts.

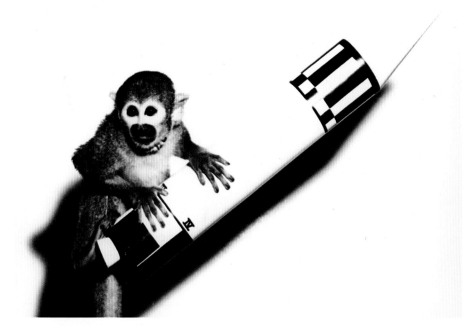

Baker, a squirrel monkey, perches on a model of the Jupiter missile that launched her into space on a sub-orbital flight, along with a rhesus monkey named Able, on May 28, 1959. Fruit fly larva and sea urchin eggs also accompanied Able and Baker, who both survived the flight; Able, though, died four days after the flight from reaction to the anesthetic given during surgery to remove an electrode. Baker died at age 27 in 1984.

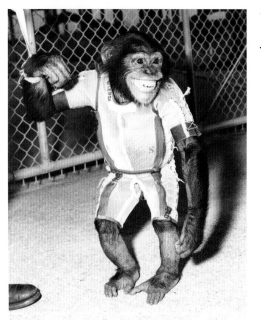

The chimpanzee Ham had a rough flight aboard Mercury mission MR-2 on January 31, 1961. A miscalculation boosted the capsule's speed almost 1500 miles per hour faster than planned, and the chimp endured almost seven minutes of weightlessness. Ham's capsule landed far off course in the Atlantic, far from rescue vessels, and seawater was beginning to flood the capsule by the time Navy helicopters found it and lifted it, with Ham inside, to safety. But throughout the flight, Ham coolly performed his assigned task – pulling levers to simulate a human astronaut's activities during spaceflight. Ham became a celebrity after his mission, appearing on the cover of *Life* magazine and making guest appearances on television programs. Commander Alan Shepard, Jr. would follow in Ham's footsteps on May 5, 1961 aboard *Freedom 7*, America's first manned spaceflight – manned by humans, that is. Ham retired to the National Zoo in Washington D.C., and later to the North Carolina Zoo in Asheboro, where he died at the age of 27 in 1983.

With the world on the brink during the Cold War, dogs once again were called to serve their country.

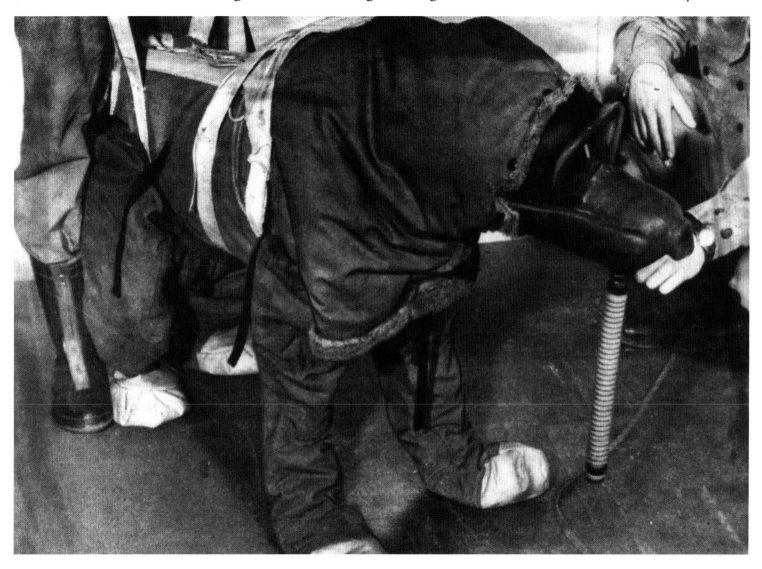

What a well-equipped dog wears at the U.S. Air Force's Wright Air Development Center, Wright-Patterson Air Force Base, 1957: cold weather gear, including booties, oxygen mask, goggles, and parachute harness. The original caption suggests that the dog is a St. Bernard, and that he is "cheerfully" aiding researchers studying physiology at high altitudes and extreme cold. It's hard to tell just how cheerful he really is, though.

An Air Force security policeman and his guard dog watch a Boeing B-52D Stratofortress taking off from an unidentified airbase during the Vietnam War's Operation Linebacker II, December 1972. Linebacker II missions hit targets in and around Hanoi and Haiphong. Missions ended on December 30 when the North Vietnamese agreed to resume cease-fire negotiations. A cease-fire agreement was signed on January 23, 1973.
George Allison Photograph Collection.

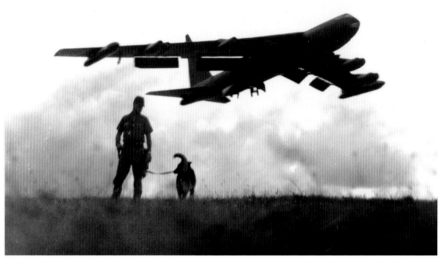

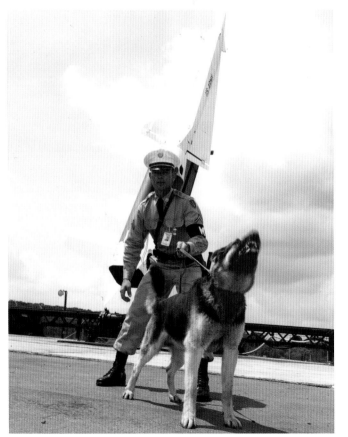

Nike antiaircraft missile sites were located around large American cities in the 1950s and '60s. They were interesting places and open to the public – I remember a fascinating tour of one with my Cub Scout pack some years ago. But vigilance also mattered. Here, a military policeman and a very vigilant guard dog are on duty by a Nike-Hercules SAM-A-25 surface-to-air missile in firing position on the launcher at an unidentified air defense base, c.1962. Today, many of the old Nike sites are public parks. There are no more missiles popping out of their pits for Cub Scouts to admire, and any dogs on site are just there for "walkies."
Herbert Stephen Desind Collection.

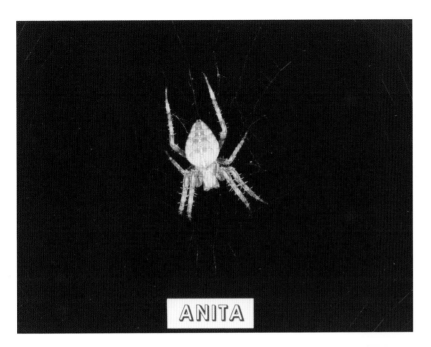

ANITA

Can spiders spin webs in the weightlessness of space? That was the mission of Anita and Arabella, two cross spiders (*Araneus diadematus*) during the Skylab 3 mission on the Skylab space station in August 1973. The experiment was proposed by a Lexington, Massachusetts student, Judith Miles. Once in orbit, astronaut Owen Garriot released the spiders into a window frame-shaped experiment cage. After a day of getting used to microgravity, Arabella spun her first web; Anita followed with one of her own soon after. The spiders were treated to bits of filet mignon contributed by the astronauts, but Anita died on September 16, and Arabella was found to have died after the crew returned to Earth on September 25.

By comparing Anita and Arabella's weightless webs with pictures like this pre-flight web, Miles learned that the thread spun in flight was finer than earth-bound webs.

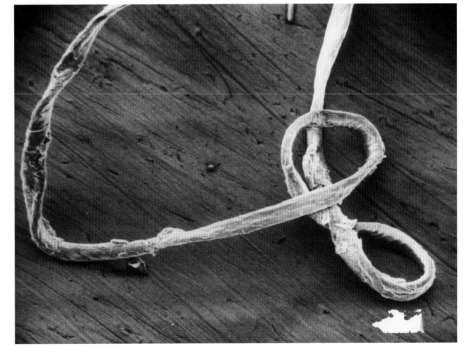

93

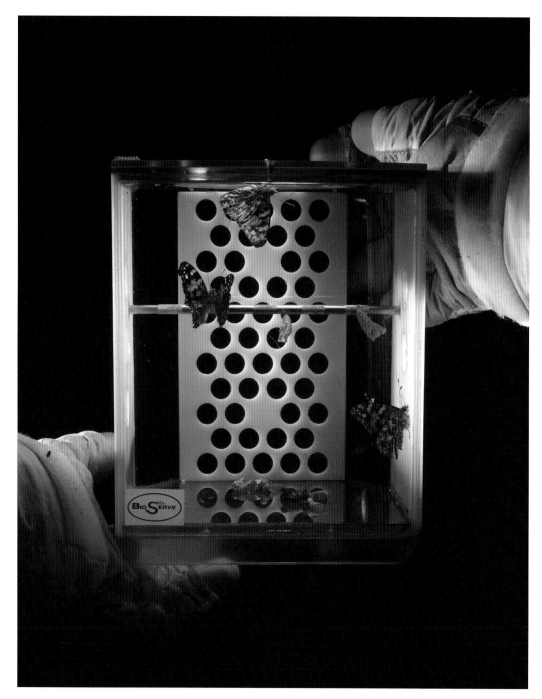

High school students from Albany, Georgia, explored the effect of a lack of gravity on the metamorphosis of painted lady butterflies (*Cynthia cardui*) in a 1997 experiment, which later flew on *Columbia's* STS-93 mission in July 1999. The students stocked the Lexan box they had designed with painted lady larvae and chrysalises, which seemed to develop normally in flight. The larvae formed their own chrysalises while floating about, and tiny butterflies emerged from their own chrysalises. After the mission, the students donated box and butterflies to the National Air and Space Museum; they're on display at the Museum's Steven F. Udvar-Hazy Center in Chantilly, Virginia. *Photograph by Eric F. Long.*

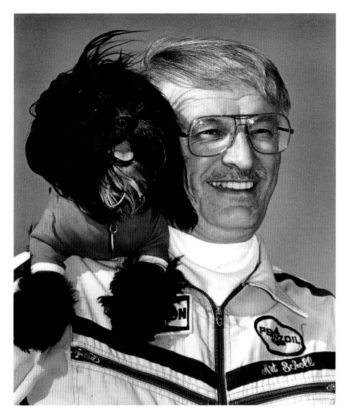

Art Scholl (1931-1985) was a renowned aerobatic pilot – a member of the U.S. Aerobatic Team for nine consecutive years and an instructor of aerobatics. Scholl was a Hollywood stunt pilot (he died in 1985 during the filming of the movie *Top Gun*), and he was also a professor of aeronautical engineering. He flew over 185 different types of aircraft. And he often performed at air shows with his dog Aileron, seen here in her stunning custom flight suit.
Art Scholl Aviation Collection.

Aileron enjoyed stunting while perched on Art Scholl's shoulder in the Super Chipmunk, Scholl's heavily modified de Havilland Canada DHC-1A Chipmunk. Aileron also liked to ride on the Chipmunk's wing while Scholl taxied on the field. Art Scholl's *Super Chipmunk* is on display at the Steven F. Udvar-Hazy Center.
Art Scholl Aviation Collection.

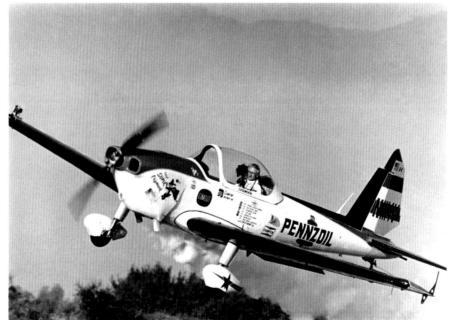

Bibliography

Allen, Richard Sanders. *Revolution in the Sky*. New York, 1988.

Bell, Dana, ed. *The Smithsonian National Air and Space Museum Directory of Airplanes: Their Designers and Manufacturers*. London, 2002.

Brooks, Peter W. *Zeppelin: Rigid Airships 1893-1940*. Washington, D.C., 1992.

Cross, Wilbur. *Ghost Ship of the Pole: The Incredible Story of the Dirigible Italia*. London, 1960.

Crouch, Tom D. *The Eagle Aloft: Two Centuries of the Balloon in America*. Washington, D.C., 1983.

Doolittle, James H. with Carroll V. Glines. *I Could Never be so Lucky Again: An Autobiography*. New York, 1991.

Finne, K. N.; ed. by Carl J. Bobrow and Von Hardesty. *Igor Sikorsky: the Russian Years*. Washington, D.C., 1987.

Genêt, Edmond Charles Clinton; ed. by Walt Brown, Jr. *An American for Lafayette: The Diaries of E. C. C. Genet, Lafayette Escadrille*. Charlottesville, 1981.

Gillispie, Charles Coulston. *The Montgolfier Brothers and the Invention of Aviation, 1783-1784*. Princeton, 1983.

Gimbel, Richard. *The Genesis of Flight: The Aeronautical History Collection of Colonel Richard Gimbel*. Seattle, 2000.

Glines, Carroll V. *Roscoe Turner: Aviation's Master Showman*. Washington, D.C., 1995.

-------. *Round-the-World Flights*. New York, 1982.

Hall, James Norman. *High Adventure: A Narrative of Air Fighting in France*. Boston, 1918.

Immelmann, Franz; trans. Claud W. Sykes. *Immelmann, The Eagle of Lille*. London, 1935.

Mabley, Edward. *The Motor Balloon "America."* Brattleboro, 1969.

Parsons, Edmund C. *High Adventure: The Story of the Lafayette Escadrille*. Garden City, 1937.

Rich, Doris L. *The Magnificent Moisants: Champions of Early Flight*. Washington, D.C., 1998.

von Richthofen, Manfred; trans. T. Ellis Barker. *The Red Battle Flyer*. New York, 1918.

Treadwell, Terry C. and Alan C. Wood. *German Knights of the Air 1914-1918: The Holders of the Orden Pour le Mérite*. London, 1997.

Wellman, Walter. *The Aerial Age: A Thousand Miles by Airship Over the Atlantic Ocean*. New York, 1911.

Wooldridge, E. T. *Focus on Flight: The Aviation Photography of Hans Groenhoff*. Washington, D.C., 1985.

-------. *Images of Flight: The Aviation Photography of Rudy Arnold*. Washington, D.C., 1986.

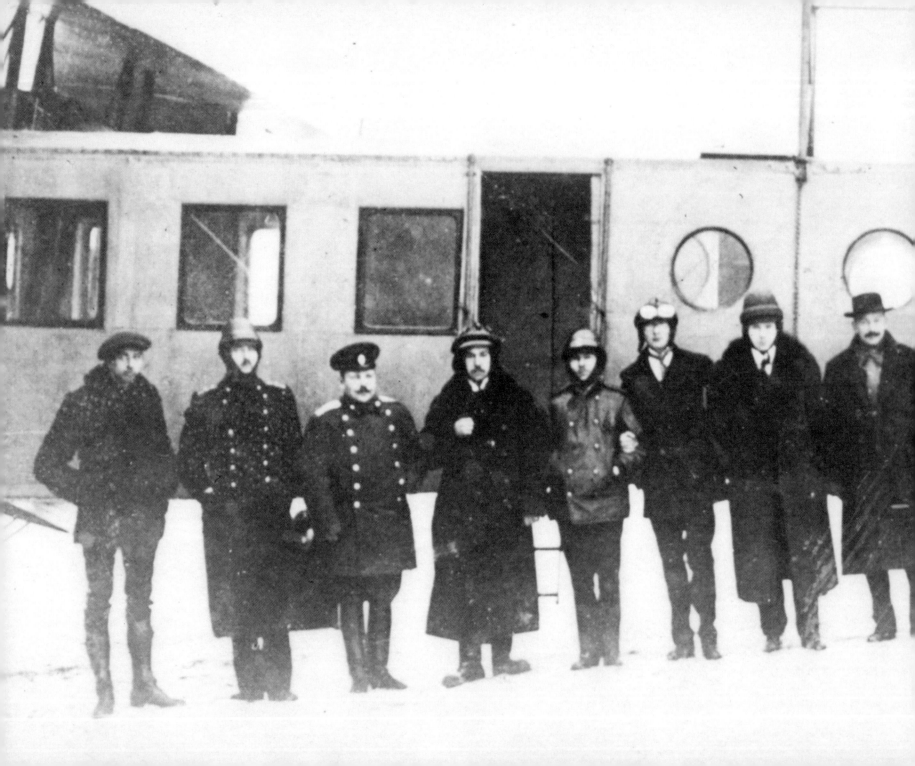